HOW
BOOKS
Cincinnati, Ohio
www.howdesign.com

The Word It Book

Speak Up presents a gallery of interpreted words

Edited by
the founders of
Speak Up
Bryony Gomez-Palacio
and **Armin Vit**

Foreword
by
Ellen Lupton

Players/roles

Bryony Gomez-Palacio designer, writer, editor, photographer, manager, e-mail master, cop and model.
Armin Vit editor, photographer, Googler, opinionated softy and model.

Amy Schell editor, motivator and teacher.
Grace Ring consultant, negotiator and link.
Greg Nock production coordinator.

11 10 09 08 07 5 4 3 2 1

Distributed in Canada
by Fraser Direct
100 Armstrong Avenue
Georgetown, ON, Canada L7G 5S4
Tel (905) 877-4411

Distributed in the U.K. and Europe
by David & Charles
Brunel House, Newton Abbot,
Devon, TQ12 4PU, England
Tel (+44) 1626 323200
Fax (+44) 1626 323319
E-mail: postmaster@davidandcharles.co.uk

Distributed in Australia
by Capricorn Link
P.O. Box 704
Windsor, NSW 2756 Australia
Tel (02) 4577-3555

Library of Congress Cataloging-in-Publication Data

The word it book : Speak Up presents a gallery of interpreted words / edited by the founders of Speak Up, Bryony Gomez-Palacio and Armin Vit ; foreword by Ellen Lupton.
 p. cm.
Includes bibliographical references and index.
ISBN-13: 978-1-58180-925-1 (pbk. : alk. paper)
ISBN-10: 1-58180-925-5
1. Graphic arts--History--21st century--Themes, motives. 2. Symbolism in art. I. Gomez-Palacio, Bryony. II. Vit, Armin.
NC998.4.W66 20072006035111
760.09'05--dc22 2006035111

fw
F+W PUBLICATIONS, INC.

Thank you.

To you, honey. And you, sweetie.

To all of you who have made this possible... yada, yada, yada. Truly though, if it were not for all of you out there in the big wide world who love to design and have a passion for the challenge of the word, this book would not be possible. So thank you.

It would also be a different book if Amy Schell and Grace Ring, along with the staff from HOW, had not worked so hard on something they believed was worth their while. We do hope we made them laugh out loud every now and then.

The support and understanding of Obi and Lola as we pushed them aside and ignored them when we wrote, proofread, photographed, called, faxed, and e-mailed... is immeasurable. Snugs are in order.

To our families for their cheerleading qualities, to our friends for their bitching, and to the designers at large for their wanting.

About the authors

Bryony Gomez-Palacio

For Bryony, life seems like one endless trip. Having lived in Mexico City, Atlanta, Chicago and now New York, you can usually spot her as the one with the camera and the multiple questions. Curiosity, determination and passion are what define her work and her unique approach. Creativity and the brain being key interests, she lectures and conducts workshops on the subject around the country. She is co-founder of UnderConsideration and the notorious Speak Up, The Design Encyclopedia, as well as the design firm Nice. Currently, she divides her time working for clients, pursuing her own ventures and teaching at the School of Visual Arts.

Armin Vit

Born and raised in Mexico City, Armin is a graphic designer and writer now living in Brooklyn, New York. He has written for AIGA's *VOICE*, *Emigre*, *Eye*, *Creative Review*, *HOW* and *STEP* magazines, among others. He is a former faculty member of Portfolio Center and currently teaches at the School of Visual Arts. He has lectured on topics ranging from Typography to Branding in locations ranging from San Diego to Berlin. He is founder of the (in)famous Speak Up, and co-founder of UnderConsideration and most recently The Design Encyclopedia. Currently, he spends his daytime working at Pentagram. Feisty behind the keyboard, Armin remains timid at heart.

What they are up to:

UnderConsideration Dedicated to the progress of the graphic design profession and its practitioners; at times intangible, its purpose is to question, push, analyze and agitate graphic design and designers. underconsideration.com

Speak Up The (in)famous online forum that has challenged the design profession with honest, daring and passionate dialog. underconsideration.com/speakup

The Design Encyclopedia A user-built source of reference material with the sole intention of defining, describing, chronicling and documenting the world through design in all its implications and manifestations—from the visual to the tactile, from the communicative to the evocative, from the cultural to the commercial. thedesignencylopedia.org

They also tend to every need of their cats **Obi and Lola.**

Table of contents

Foreword

Skip Intro

When it comes to wearing hats, Ellen has a closet full of them and keeps some in storage. As a writer, designer, educator, curator, outspoken DIYer and mother of two (thank you very much), she champions design in a bevy of fashions from a variety of outposts including the Cooper-Hewitt National Design Museum, Maryland Institute College of Art and her townhouse in Baltimore. Step into a bookstore and browse any of her widely popular books: *Thinking With Type: A Critical Guide for Designers, D.I.Y.: Design it Yourself, Skin: Surface, Substance + Design* and *Design Writing Research.* Or step online and find her maintaining designwritingresearch.org, where you will find a satisfying collection of her writing, or you can visit design-your-life.org and d-i-y-kids.blogspot.com and unleash your own DIY attitude.

A funny thing happened to graphic design a couple of years ago. Designers started talking to each other. Sure, we had always found a way to chat. We talked to each other in the breakfast line at design conferences large and small, where Big Speakers took the stage and everyone else sat in the audience. We organized local AIGA chapters and advertising clubs, where we could attend community picnics, take tours of printing plants, and invite more Big Speakers to address us from the local stage. We read design magazines, and we could submit a letter to the editor if we wanted to take the trouble.

All that started to change when a few web sites began posting articles about design and inviting direct, immediate feedback. One of the first was Speak Up, founded in 2002, followed a year later by Design Observer. These web sites created an unprecedented opportunity for everyday designers to join a discourse about what we do. Although the Weblog medium dates back to the early 1990s, blogging blasted into public view during the presidential election of 2004, when independent, unaffiliated writers, both red and blue, trailed

the candidates' campaigns on their own blog sites. Suddenly, the term *blogging* was everywhere. Graphic designers were already there, of course, plugged into the scene via web sites like Speak Up.

Since the beginning, Speak Up has been recognized for both its elegant format and its down-to-earth, design-relevant content. Whereas some of the other design blogs were using standard templates (Design Observer is now custom-designed after three years) or belonged to ubermedia sites that allowed little visual expression (UnBeige), Speak Up originated a fresh visual texture on the web. It is a texture that looks remarkably like print. The white backgrounds, the subtle typographic hierarchy, the low-key, high-functioning ornamentation of a text-driven information structure—these features all draw on the print tradition, brilliantly recrafted for online communication. And then, amid all that text, there is Word It: an ongoing visual project that invites users—and attracts hundreds of them—to respond to a different word each month within a constrained visual format.

Why do people make Word Its? Word Its don't get you paid, and they
won't make you famous. Yet people take a lot of pride and pleasure in crafting their Word Its, submitting them to Speak Up, and stopping by to see how their art behaves in the company of strangers. Making a Word It is an individual act. Each piece stands alone, taking its own strange or funny view of the challenge word, but what makes Word Its work is the collection—the assembly of diverse attempts and oddball efforts.

Why do people like to look at Word Its (and why might you be looking at this book)? Word Its are somewhere between cartoons and art. They have succeeded in defining a design genre that (almost) stands alone. Most of what designers make depends on a client. Book covers, posters, brochures and cereal boxes: these get produced and consumed in relation to other products. Every Word It needs the context of other Word Its, but it doesn't need to sell anything. A Word It is what it is: a crisp, concise response to a word, five inches square. Each one was created to entertain, to provoke, to inspire or to roll over on its back and ask for love.

Word Its can be funny, sad, harsh, political, illustrative, obscure, obvious or abstract. Anyone can make one (as long as you follow the directions). The best ones have been collected here.

This is not the first printed book to be published by Speak Up, and I doubt it will be the last. You can start from the beginning and read every page, or you can flip through and see what catches your attention. If you are left-handed, like I am, you'll probably start from the back. You don't have to download an animated film (much less read this foreword) before you get started. Like most books, this one lets its users do pretty much whatever they want with it. It's nonlinear, user-friendly and created by its own public.

Word It: It's a book, it's a blog, and it's yours.

by Ellen Lupton

Once upon a time...

This conversation took place on a Saturday night, when two geeks sat across from each other while relying on technology and a wireless connection to keep the dialogue going. Later, they had pumpkin tortellini for dinner.

BGP: You know, I still remember the day you approached me with the initial ideas of what Word It was to become. It was one of those, "Sweetheart ... ?" kind of moments.

AV: Yes, I can't believe I felt like I was doing something "wrong." But it was the first time we were going to introduce any sort of imagery on Speak Up, after taking a stance that Speak Up would be all text all the time. But even the idea of Word It wasn't defined yet... I just thought it would be nice to have some sort of image somewhere on the site that would constantly change. Talk about open-ended...

BGP: I know, that is why it didn't really seem to be working in the beginning. We started with the obvious (and now embarrassing) cliché, "inspiration." It was up for a couple of months and we received multiple variables but none really struck a nerve. Then there was "window." Oy!

AV: Well, we didn't really know where we were headed with this. "Inspiration" does seem a tad unimaginative. Although it's important to note that this first version of Word It was very different: People had to come up with a word that meant inspiration to them—so we had submissions that ranged anywhere from "love" to "primates" to "geopolitical." It just got very scattered, quickly running in all directions. Also, to get this first round started, I solicited the first 20 or 30 contributions. It wasn't until those were up that people started participating. "Window" was our second attempt, when we decided to switch to the we-tell-you-what-word-to-work-with approach. I actually enjoyed some of the "windows"...

BGP: In the beginning, managing the Word Its was up to E. Tage Larsen, former Speak Up author. Announcing and selecting the words, he did a really good job of getting it started—entries were not numerous, but in general there was quality and wit, things we keep looking for.

AV: He came in after we let "window" sit inactive for a month. He was the one that pushed to institute a monthly timeline and a little more rigor. That's when we started asking for high-resolution files as well, just in case we ever... were in this exact situation right now. Doing a book.

BGP: Well, if you don't mind my saying so, we have always been visionaries. But I have to mention that somewhere around "giant" or "parody," Word It seemed to take off. We were done talking about it, no longer strategically placing it in conversations but letting it all run its course.

AV: After a couple of slower starts with "nightmare" and "virtue," lighter words started to grab people's attention, and more people started submitting and linking Word It in their own blogs. Even teachers started taking notice and began using Word It as a class assignment. After you took over and started mixing up serious and lighthearted words, it really stuck and people started getting into it more and more.

BGP: I always wanted to do "oops," and I was excited about proposing "pleasure." I realized rather quickly that we have a broad and wide-ranging audience—some like to be thoroughly challenged, while others just want to have fun. Striking a balance and keeping everyone in anticipation is my job, and I love it. For some time I have been wondering, what has been your favorite word or moment since we started Word It?

AV: I think "prank," "hot" and "what" are at the top. David Werner, Mark Kingsley, Marian Bantjes and Pesky Illustrator are usually my favorite contributors.

BGP: I just ran the final numbers, and they are making me feel proud. For this book, we considered 1,747 Word Its submitted by over 600 people. An amazing feat, and one heckuva creative group.

AV: We should also note that we have formatted 1,747 Word Its for publication online. And this has become your Sunday morning ritual. Funny, huh? Right?

BGP: Yeah, right. As we were saying… I have noticed some of our contributors have certain rituals as well—be it sending Word It in the day the word is announced, using the same typeface time after time, or reusing one image word after word.

AV: What do you look forward to in upcoming Word Its?

BGP: I believe Word It has reached a level of maturity that will allow it to move beyond a creative experiment/exercise, and it is ready to step up. What do I mean by this? I think the quality of execution, wit and thinking behind the submissions is quickly improving, and we are slowly moving away from the expected solutions. I do wish we could steer away from having to actually show the selected word within the Word It; sometimes it seems like overkill. But who am I to judge? Word It is out there not for me, but for every passerby to observe, hate, fall in love with or simply pass by.

AV: I enjoy how far-reaching Word It has become. I would like to see more international contributions to really get some different points of view on any given word. Overall, I just want people to keep coming back and doing as they please… It's invigorating to see people spend their free time on something like this. It points to the fact that most designers do what they do because they love it, not only because they have to.

BGP and AV: Now, as you embark upon the Word Its, we suggest you follow this simple chart to navigate the pages, as you match author to Word It:

As you can see, it is a simple format. If one space is not used because we have a Q&A, or the same person has more than one Word It, then we omit the matching name. No need to repeat ourselves, right?

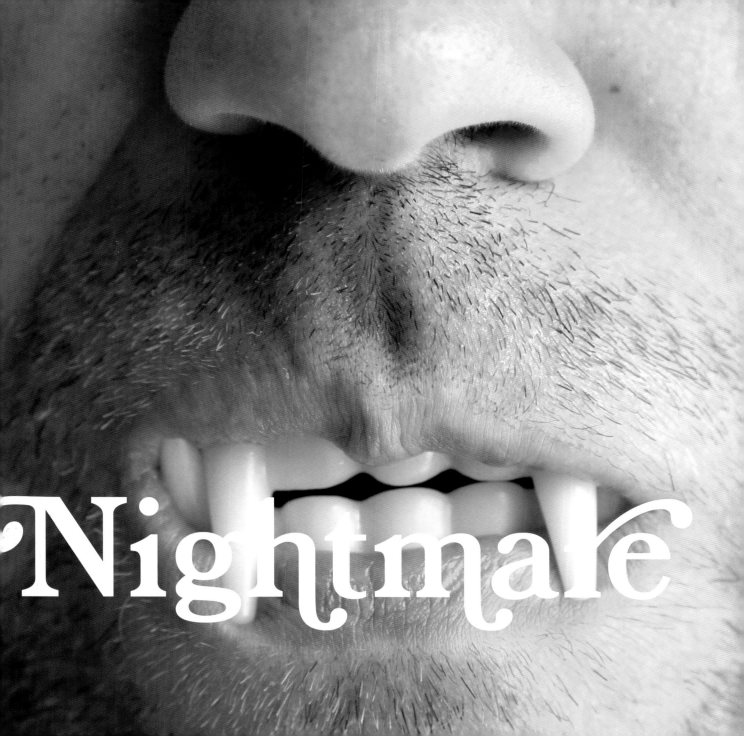

Date
October 2003

Total Word Its
32

Number of participants
29

Recurring themes
monsters
fangs
eyes

Software-related
2

Mama!!!
Mama?
Ma!?

"It was happening again. I was sitting at my desk, my coffee was lukewarm, I was listening to Design Matters. I was working on this layout, InDesign was not cooperating... I could see every move of my mouse, every menu and action on the screen. Every dialog box and..."

"Shh... Darling, it's OK. You are 4.3 miles from the office, and tomorrow is Saturday. You won't be going to that place for a couple of days. Try to get some rest".

"But I made all the copy changes, and it crashed. Did I make the changes? Was that just part of the dream? I need a hard copy, a PDF. It's the only way I will know what is done, and what was darkness..."

Nightmare is the Word It for October.

SU: A lot of people have asked, what does the "R" stand for?

KYKL: I'd prefer to leave it up to the viewer's imagination.

Kevin Yuen-Kit Lo

Rick Goral

Rick Moore

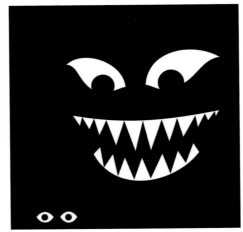

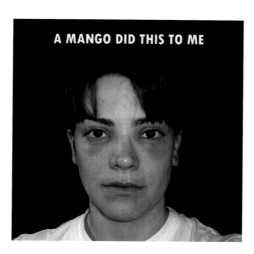

A MANGO DID THIS TO ME

HELL FROZE OVER AGAIN.

INTRODUCING
Mac OS XP
only $1799

Erin Rothenbuehler

Juna Duncan

SU: Please tell us about this mango and its side effects.

ER: One day I enjoyed the taste of paradise. Two days later, tiny liquid-filled blisters broke out on my lips; itchy little red dots and swelling soon followed. My husband, in a misguided attempt at cheering me up, joked that it looked as if someone had clubbed me with a bag of oranges.

The allergist saw me a month later with a photo in hand. He was unable to offer more than "dishwashing gloves" or "unknown plant". Only I could be that allergic to the delicious taste of paradise.

"Do you mind if I keep this?" he said looking down at my photo, just before I left.

SU: Did you ever think your nightmare would actually come true, now that Macs can run Windows?

JD: I remember that I made this illustration after Apple announced the iPod for PCs. What a big thing that was. At the time I didn't think Mac would ever run Windows. My real nightmare though was that the new Mac OS would be just like Windows. After the announcement of the Intel chip, it was pretty obvious that Mac would one day be able to run Windows. Thankfully Mac has kept their wonderful OS X. The real question is "What more can Apple do?" Maybe each computer will ship with XP and OS X together. That would be something.

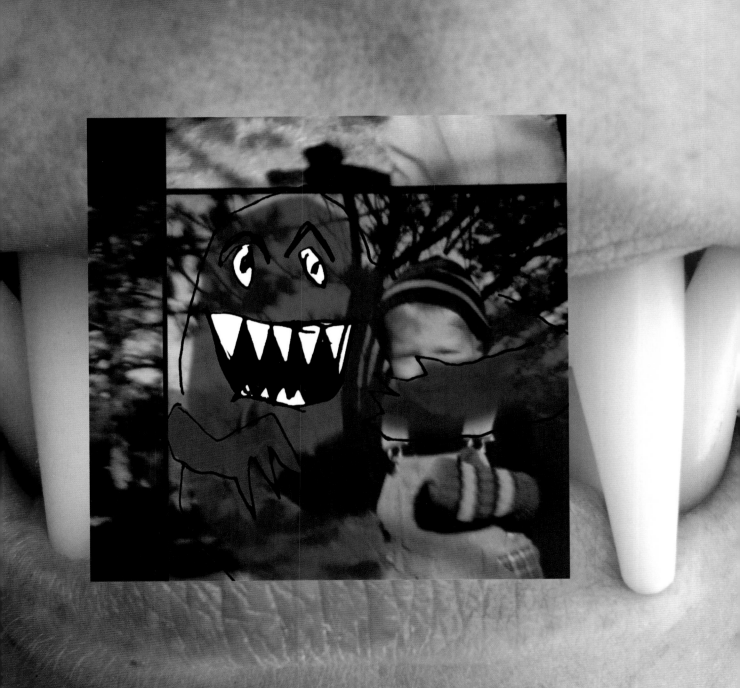

Paul Kimball

Paul is a designer, songwriter and father of two living in San Jose, CA. He's written two fan letters in his life: one to Sammy Davis, Jr., and one to Henry Rollins. He's contemplating writing a third, (recipient yet to be selected).

SU: You have an interesting combination of photography and illustration. How did you go about creating it?

PK: The photo was taken during my brief flirtation with Lomography, a philosophy of photography which strives to honor the loose and accidental for its intrinsic beauty. In keeping with this, cheap and unpredictable cameras are the preferred tools. Mine was a Lomo Action Sampler, which shoots four images in rapid succession on a single frame of 35mm film, and my son Milo is the subject—being his high-energy self. I really liked the rich, saturated colors in this image, and I knew I'd use it for something at some point. For the illustration part of it, I tried to stay consistently loose, largely just mouse-painting into the image with Photoshop.

SU: Tell us about your nightmare. It looks quite terrifying.

PK: Thanks! It sure looked scary to me, too. Two things are at play here: the intense terror I experienced in nightmares as a child (even when the haunt was something kinda cartoon-like) and the similarly intense fear I now feel of some unnameable horror befalling either of my children.

SU: How much time did you devote to the task at hand?

PK: About two hours, messing with different "ghosts," croppings and color schemes.

SU: Did you end where you started? Or did it evolve and change?

PK: It actually changed quite a bit… the ghost started out as much more of an adult horror movie-like effect. But I wound up with something more like a kid's idea of something scary.

SU: You are a recurring participant, which is why we like you so much. Why do you find yourself coming back?

PK: Aw, shucks… the pleasure is mine. Word Its are just carefree playtime for me, that's why I like 'em. They allow me to act like an illustrator for a little while, which is something I often fantasized about becoming but for which I never really had the drawing skills.

SU: What kind of words do you find the most alluring?

PK: If you are talking about Word It words, it's the ones I have the slack in my schedule to actually do! I can't say I favor any one kind of subject over another: Word Its are just good creativity drills, and the kind of mental muscles they exercise really can't suffer from overuse. If you mean words in general, I love words that have melodic and rhythmic personality, like "cantankerous," "brittle," "ravenous" and "quenched." When someone uses language with both precision and musicality, either in speech or in writing, I tend to be first in line to appreciate that.

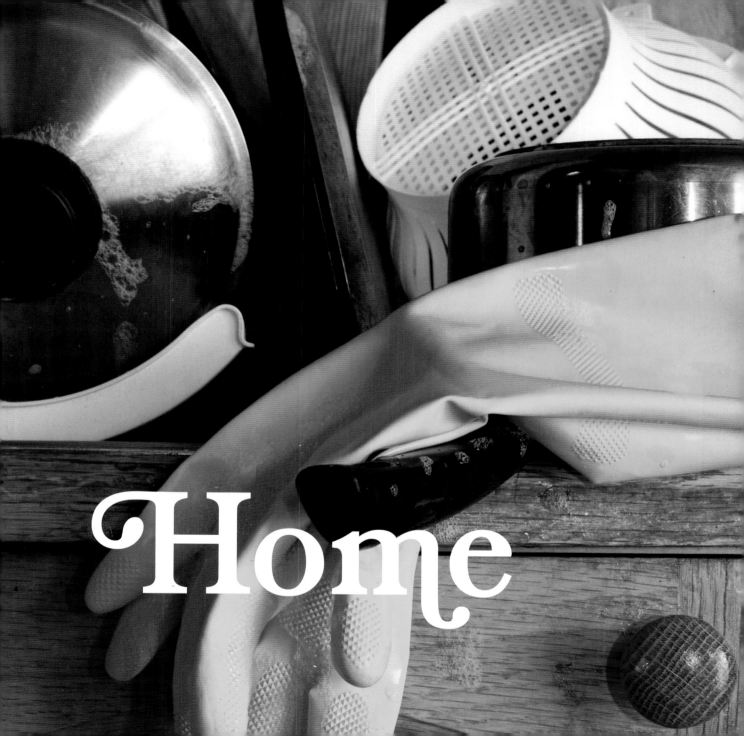

Home

Date
November 2003

Total Word Its
24

Number of participants
20

Recurring themes
location
people

River canals
2

An isolated smell down the street as you walk to the cleaners can take you there. A child's voice in the park, an image in the paper, or a heavy rain. It is the everyday things that can, after years have gone by, take us to that one special place we call home. It might be the house you grew up in, your first property, or that place you dream about.

Home is more than an address—it is a state of mind, a cluster of memories. Home is literally where the heart is. Or where the heart likes to go when it feels lonely or when in search of something familiar.

Home is the Word It for November.

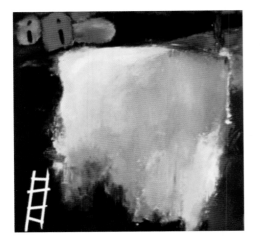

I'm always at home

SU: Your piece has both beautiful and eerie aspects to it. Can you explain how you achieved this?

DM: I have spent years being fascinated by how we live and the way we construct our lives—both with our families and as individuals. I was exploring both the physical proximity of who we live with, as well as the inherent separateness of all that we experience. I purposely used lush colors for the foreground and the houses, which I was hoping would give the piece a dreamy tonality. I was torn about whether or not the ladder belonged in the piece, but ultimately this literal bridge felt right in a piece that was looking to connect hopes and fears, the real and the imagined.

SU: What does "being home" mean for you?
LV: As a writer, being home means to inhabit my own world full of fantasies.

Debbie Millman

Laura Vit

NEW AND IMPROVED.

IT'S NOT JUST FOR THE HEART ANYMORE.

Matthew Kenyon

Michael Christian McGaddon

James Ketsdever

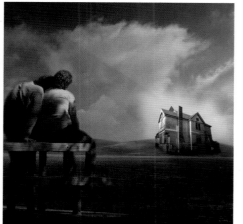

SU: **What was it like to create this piece?**
JK: I was (and usually am) surprised by the interplay of the elements. It's almost as though I'm facilitating their finding each other. If that happens (and it doesn't always) it's usually because something is resonating with me on some deeper level. Every image seems to contain a kind of potential energy, which is why I never toss my outtakes.

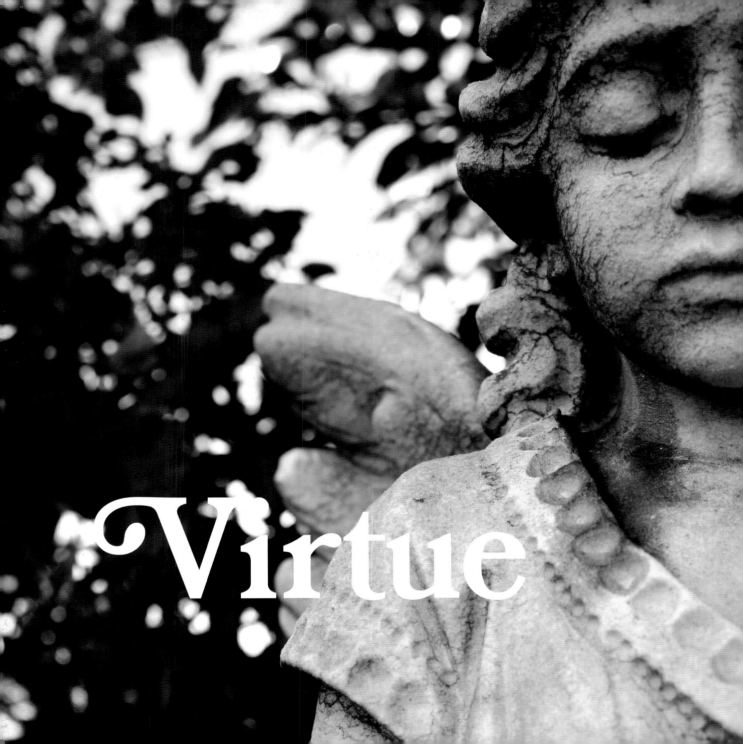

Virtue

Date
December 2003

Total Word Its
15

Number of participants
15

Recurring themes
human qualities
the color blue

Angels
3

Honesty and lies.

Kindness and cruelty.

Tenderness and silence.

Trust and betrayal.

Integrity and pride.

Grace and melodrama.

Engagement and disassociation.

Compassion and avarice.

Closeness and alienation.

Faith and desire.

Guilt and hatred.

Tolerance and impatience.

Generosity and disdain.

Optimism and remorse.

Virtue is the Word It for December.

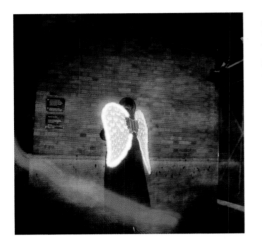

Todd Davis

Joy Olivia Miller

Todd Davis

Joy Olivia Miller

SU: What did you have to do, start to finish, to create this image?

TD: Woo! This image has been hanging around since November 2002. I snapped it really quickly when I saw this lady wearing the wings walk out of the Liverpool Street Station around 6PM. I used a Canon Elph Powershot 400. I think I originally sent this to Armin and I had added a sign for the Underground, but Armin suggested that maybe it was too distracting. I rotated the image, removed the Pepsi can and McDonald's cup from the picture, and I used the clone tool to remove the light from the wall. I warmed up the colors a bit and rendered a spotlight on the subject.

SU: What led you to this execution?

JOM: I typeset the paraphrased version of one of my favorite quotes by educator and philosopher David Starr Jordan using gothic letters (and an antiqued background color) to help reinforce the sentiment's lasting meaning.

Wisdom is knowing what to do next

Virtue is doing it

DAVID STARR JORDAN

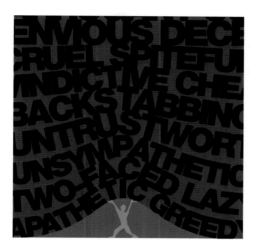

SU: The words all have a negative connotation. Can you tell us what your thinking and inspiration were?

PK: There is an abundance of people in the world who embody those (and many other) negative traits. As a consequence, I believe that to be virtuous is to be nearly heroic. The figure in my illustration is not just bearing up under the pressure, he's actually moving beyond it, into the blue… into a better place. I guess I was feeling optimistic that day!

SU: You are an avid photographer. Can you tell us a bit about his image?

PDB: Angels embody cardinal virtues, and angel figurines are a physical manifestation of their perfection.

The cardinal virtue *courage* is the opposite of cowardice. Cowardice is symbolically represented by the color yellow. This angel *is not* yellow.

Paul Kimball

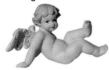

Patrick Durgin-Bruce

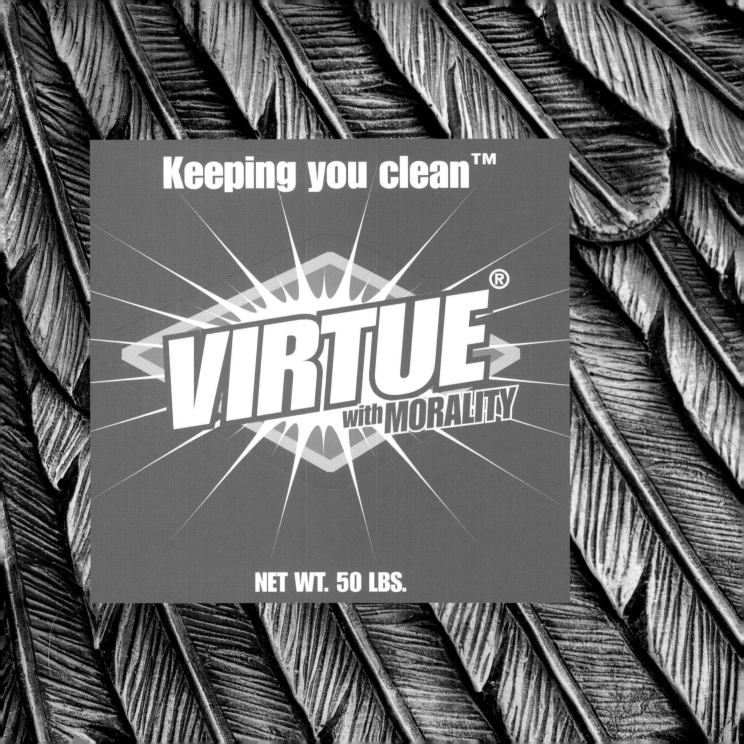

Juna Duncan

Juna is one busy guy. While running a design firm with fellow Word It participant Rick Moore, he is also the brains behind the "T-shirt design showdown" Café Clash, where designs compete against each other and are voted upon by the public.

SU: What triggered this idea?

JD: I think I went to the dictionary for this one. When I looked up "virtue," some of the words that described it were morality, chastity and Christianity. That got me thinking of keeping ourselves clean. Clean made me think of some kind of soap or detergent.

SU: Was there any particular detergent you were mocking?

JD: I was originally mocking Clorox Bleach, which of course makes everything white. I changed a few colors and decided to put a starburst behind the word to make "virtue" stand out. I also wanted to put a catchy slogan like a lot of the detergents have—then I put both the trademark and registered trademark symbols to further mock the way we advertise products.

SU: Were there any particular challenges?

JD: One of the challenges with this particular Word It was making sure that it was readable even at a small size. I also wanted to be sure that people would easily recognize that I was making fun of the fact that "virtue" is like a detergent for your soul.

SU: What is your creative process like?

JD: I like to think of the word for a while. Most of the time I jot down ideas. I then try and come up with something that I think no one is going to do. Something different. Once I get the idea I want, I sketch out how I want it to look (or I search for reference photos on the internet) and try to put it all together.

SU: Do you have any suggestions for those thinking about their first Word It?

JD: I would say you have to try and do one. Don't just type the word out and use that. Go a little further. Be creative. Have fun. Think of what the word means. Could it mean something different?

SU: What is it like to see it after several years have gone by?

JD: I still like it. It's clean (pardon the pun). It has great color contrast. Hopefully easy to understand. One thing I don't remember though, is why I put "NET WT. 50 LBS." Was I trying to say that 50 lb. kids have lots of virtue? I don't know.

SU: Well, 50 lbs is a lot of virtue.

23
virtue

Empty

Date
January 2004

Total Word Its
38

Number of participants
34

Recurring themes
software windows
brains

W. Bush
2

Soul

Heart

Brains

Personality

Affections

Opinions

Expectations

Love

Promises

25
empty

Empty is the Word It for January.

SU: Which do you consider to be the most popular "empty" conversations? What do you do to escape them?
JK: Most conversations involving sports, reality TV, or one's pets (except mine).

To escape, I just smile and nod and go to my happy place.

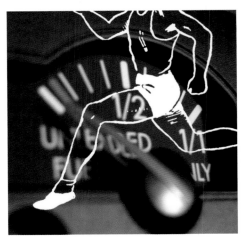

SU: This is a feeling many can relate to. What prompted this response at this particular time?
JN: At the time I thought it was simply a clever take on the word—I was struck by the visual relationship between the arc of the dial and the runner's leap. But now that I think back to that particular moment, I realize that my unconscious was trying to tell me something. When you really love what you do, it's difficult to say no to it, even if you should—you feel that your creative energy is inexhaustible. It's been two years already since I made this, and I wish I could say that I've got it all figured out by now. The fact is I'm still overcommitted, though I'm aware of it. Maybe that's a start.

Von R. Glitschka

Mark Haak

ABCDE
FGHIJK
L NOP
QRS U
VWXYZ

SU: Your style is very unique. How did it come about?

VG: I consider myself an "illustrative designer." I tend to approach my projects with the appropriate style needed. So that means I tend to work in a variety of styles both with my design and illustrative projects. The two overlap so much though—hence the revised title aforementioned.

This specific style I can trace back to its point of inspiration. Growing up, my parents had an LP collection and much of the music was "Big Band" type tunes on the RCA label. I was fascinated with the artwork on the covers and would draw my own art based on the characters I'd see. The art director from that period was the wonderful Jim Flora. It wasn't until about twenty years later that I realized how much his artwork influenced my own. By that time, unfortunately, Jim had passed away, but I was able to touch base with his son, and we talked about his dad's work. He even shared with me some of Jim's later work, which were paintings of large sea liners and boats turned on end and arranged like buildings. Very different than his earlier work but really well done nonetheless.

I refer to this style as "segmented." It's a lot of fun to create, and I enjoy the color exploration the most.

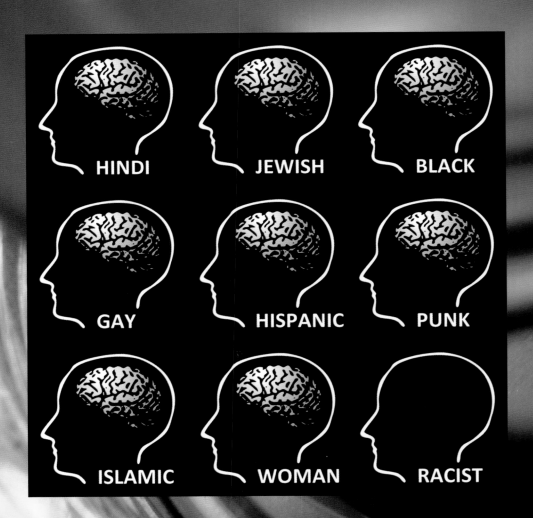

Fabien Butazzi (Koan)

Not content with design, photography and DJing, Koan dreams with a small restaurant. His favorite time of day happens when he puts a stop to the madness in order to cook for his fiancée and friends.

Experimenting with recipes and beautiful plating—while spending time with his loved ones—is the greatest luxury he has created.

SU: Simple in its execution, complex in its message. What was your Aha! moment like?
FB: You have to consider what was the historical moment when I sent you the image. We had the tragedy of 9/11, and in Italy (where I live) the right wing reached the government. This was immediately followed by two more tragedies: the assassination of Carlo Giuliani during the G8, and the rise of the Lega Nord (the Italian xenophobic party and trusted allies of Silvio Berlusconi). Apart from Giuliani's death, these happenings caused a massive campaign against Islam and communists (the Patriot Act in the U.S. and a growing racism in my country, for example), but the true result was to add hate to hate. You can understand that the surroundings were not so shiny, and your Word It project came at the right moment to translate my bad feelings into images.

SU: This is a very strong message. Did you at any point consider not submitting it?
FB: Never. What I have explained before means that I was really motivated. As I said, it was important to me to find a positive way to translate my bad feelings.

SU: Brains are hard to draw. How did you go about creating this one?
FB: A lot of patience, which I need it again now that you are asking me for a high resolution version of a file lost years ago.

SU: Did you use the profile of somebody you know?
FB: Oh no. The objective was to draw an anonymous profile because everyone could be part of this image or feel as if he was, even you and me. We're all identical… well, we all have differences of course—we're all made of the same flesh, hair, heart, etc., and we all have a functioning brain. Except for one…

SU: What motivates you as a designer?
FB: Well, maybe there's nothing more than passion. I started as a web designer in 1996, and I assure you it was a hard task to become known and appreciated enough to have a decent working life. But arts and design were my passion since I was a child—even if I studied Philosophy instead of Arts. These days, I feel good with what I became and with the way I'm cultivating my little garden, if you see what I mean…

Yes, I think passion is the best word.

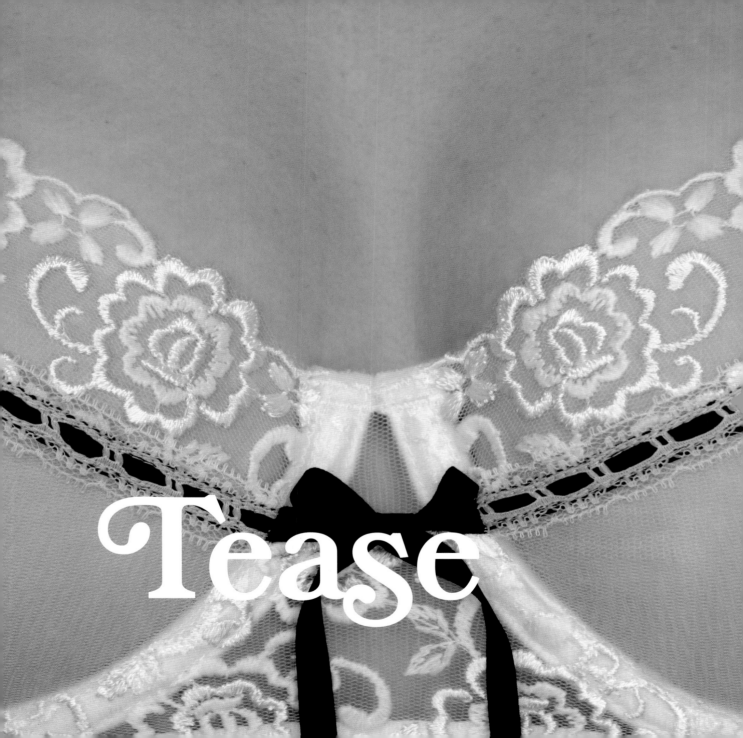

Date
February 2004

Total Word Its
37

Number of participants
33

Recurring themes
sex
love
celebrity

Suggestive boobs
3

He loves me, she loves me not. She loves me, he loves me not. He loves me, she loves me not. She loves me, he loves me not. He loves me, she loves me not. She loves me, he loves me not. He loves me, she loves me not. She loves me, he loves me not. He loves me, she loves me not. She loves me, he loves me not. He loves me, she loves me not. She loves me, he loves me not. He loves me, she loves me not. She loves me, he loves me not. He loves me, she loves me not. She loves me, he loves me not. He loves me, she loves me not. She loves me, he loves me not. He loves me, she loves me not. She loves me, he loves me not. He loves me, she loves me not. She loves me, he loves me not. He loves me, she loves me not. She loves me, he loves me not. He loves me, she loves me not. She loves me, he loves me not. He loves me, she loves me not. She loves me, he loves me not. He loves me, she loves me not. She loves me, he loves me not. He loves me, she loves me not. She loves me, he loves me not. He loves me, she loves me not. She loves me, he loves me not. He loves me, she loves me not. She loves me, he loves me not. He loves me, she loves me not. I love him, I love her not.

Tease is the Word It for February.

SU: Was this your first idea? The last one? Can you send us the other half?

MZ: With Word Its I tend to go with the first idea that pops up. This was the one and only attempt for "tease." As far as sending the other half, I'm going to have to ask for age verification. Viewing full flesh colored circles can corrupt children and society as a whole.

Michael Ziegenhagen

Tricia Bateman

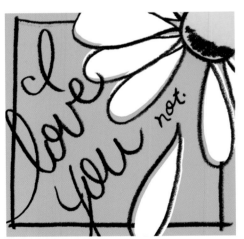

SU: The conundrum of the human condition. After all this time, is there anything you would change in your submission?

TB: It would have read better as "He loves me not." Does that say something about where my mind was at the time?

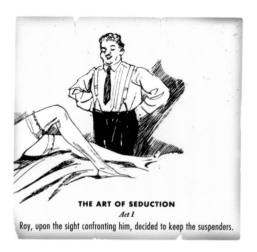

THE ART OF SEDUCTION

Act I

Roy, upon the sight confronting him, decided to keep the suspenders.

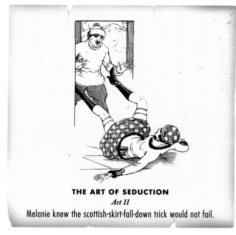

THE ART OF SEDUCTION

Act II

Melanie knew the scottish-skirt-fall-down trick would not fail.

THE ART OF SEDUCTION

Act III

Victoria's ballet shoes came undone not by mistake, and they knew it.

Armin Vit

33
tease

SU: How do you describe your sense of humor? Where does it come from?

AV: I would describe it as smart-assed and under-the-surface. I make connections in my head about what I am seeing and/or hearing with other things I have seen and/or heard, and I try to combine them in a funny, irreverent way. Sometimes it works; sometimes it painfully doesn't. In this specific case, I was thinking of *The Far Side* calendars and the absurd commentary they apply to their absurd illustrations. I find Act I the funniest: Mustached guy getting it on with his suspenders on. Funny, right?

Marian Bantjes

Marian has created quite a stir in the design world. Her hard-nosed, inquisitive personality, her beautiful work, her obsessive solutions, and her strong opinions are common dinner topics.

SU: Your beautiful and intricate style mesmerizes in its simplicity. Is this something you strive for? If so, how?

MB: Actually, I've been thinking about this a lot lately, especially with consideration to my training (and ten years of work) as a book typesetter. I've never been trained in the International Typographic style, but I do know it to a certain degree, and I've come to realize how much my knowledge of working with grids, working in a "classical" book layout, and a very formal approach to typography has influenced my much more organic, florid approach. Since becoming conscious of this, it is now something I'm trying to work with in a more overt manner. I've also been recently thinking a lot about layout, design and the use of space. I actually think my work has things in common with the Swiss style, and much of it is apparent in the use of space, as well as in control.

SU: One of your trademarks is your subtle sense of humor. How do you infuse that in your work?

MB: Heh heh. I wish all my work was funny. The projects I'm happiest with are often ones that have this humorous perspective. I just did a piece that I summed up as "pretty, funny and smart," which makes it perfect—for me. However, in my opinion, any humor that is forced is no longer funny, so it's hard sometimes to just make something funny. Sometimes this is a huge stumbling block for me that I just have to abandon. If I find the humorous aspect, then great; but if not, I run a risk of ruining the design by trying too hard. Sometimes it's so subtle no one sees it but me.

SU: Is it Obsessive Compulsive Disorder? Or simple determination?

MB: Definitely OCD. When I get to the level of making something by determination, it's a chore, and not likely to turn out very well.

SU: Should lace be making a comeback?

MB: Well, yeah. It kind of is already; there's a lot of lace and eyelet-ry in fashion these days, but I don't think anyone is looking at it closely enough. I'd love to design some lace. It would definitely be funny lace. We need more humor around tits and sex.

Giant

Date
March 2004
Total Word Its
50
Number of participants
31
Recurring themes
life
beasts
exaggeration
Heroic photography
2

Abbott Miller and Ellen Lupton. Alan Dye. Alexander Isley. Alice Twemlow. Alvin Lustig. Ann Willoughby. April Greiman. Art Chantry. Barry Deck. Bill Grant. Bradbury Thompson. Brian Collins. Bruce Mau. Carin Goldberg. Carlos Segura. Charles and Ray Eames. Chip Kidd. Christopher Simmons. David Carson. Debbie Millman. DJ Stout. Ed Fella. Erik Spiekermann. Gail Anderson. Hillman Curtis. Hjalti Karlsson and Jan Wilker. James Victore. Jeffrey Keedy. Jessica Helfand and William Drenttel. Jonathan Hoefler and Tobias Frere-Jones. Lester Beall. Lorraine Wild. Louise Fili and Steven Heller. Maira and Tibor Kalman. Marc English. Matthew Carter. Michael Bierut. Michael Ian Kaye. Milton Glaser. Neville Brody. Noreen Morioka and Sean Adams. Paul Rand. Paula Scher and Seymour Chwast. Peter Buchanan-Smith. Peter Saville. Rick Poynor. Rick Valicenti. Saul Bass. Scott Stowell. Stefan Sagmeister. Stephen Doyle. Woody Pirtle. Zuzana Licko and Rudy VanderLans. Little me.

Giant is the Word It for March.

Chris Vivion

Steven Soshea

SU: Any particular experience or situation in which this was particularly true?

CV: Who doesn't experience a moment, now and again, when the idea of "themselves" extends itself a bit too far?

SU: Do Barry Bonds' continued steroid-use accusations diminish his achievements as one of baseball's top sluggers?

SS: When he says that he never knowingly took steroids, I think he's telling a half-truth: Willfully ignorant and trying to stay competitive. And then he got caught crossing the line and was put under a microscope. I think Barry is an amazing player regardless. He still commands a lot of respect on the field, and Giants fans still love him. So I say to those purists, stick an asterisk next to his name (and others) in the stat books, and move on.

IT WAS THIS BIG

Michael Christian McGaddon

[Screaming, sirens]
Nancy, people are running everywhere, it's pandemonium outside Capitol Hall, authorities have evacuated the Mayor and are urging people to leave the city, since its behavior is quite unexpected. Reporting live, Gloria Hill, CNN. Back to you at the studio.

[Wind blows, fires rage]
Nancy, it seems like the first wave of rampage is over. Police and firefighters are taking advantage of its current state of tranquility, however, they know that it could awaken and attack again. Reporting live, Gloria Hill, CNN. Back to you at the studio.

[Crowds cheering]
Nancy, the moment we have all been waiting for: Armed forces came in and finally captured it and will be releasing it to the wild. The streets are once again safe and people are celebrating. What an ending! This has been Gloria Hill, reporting live. Now back to your scheduled programming.

DISCLAIMER

No kitties were hurt in the production of these Word Its.

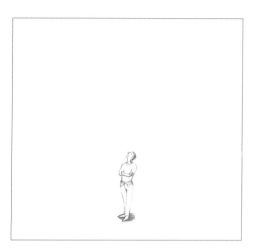

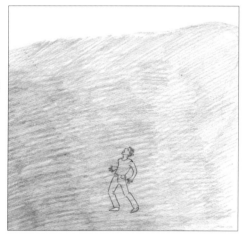

Marian Bantjes

SU: Your Word Its are very simple, yet there is a mixture of strong feelings, storytelling, expectations and dread that draws you in. Was this your original intention? How did it all come about?

MB: Well, despite the fact that I don't call myself an illustrator, I guess this is what illustration is: representing the unseen. Also, with the Word Its, the interesting part is the vast amount of interpretation you can get from a single word… not only in how to represent the word, but what it actually refers to. This one, "giant," well… giant what? In my first Word It for this, the giant is an object of interest or curiosity to the man… clearly there is something larger that he is looking at. In the second Word It, however, there is a sense that the giant is no longer benign. It could be threatening, advancing or falling, but the rest is up to the viewer to decide.

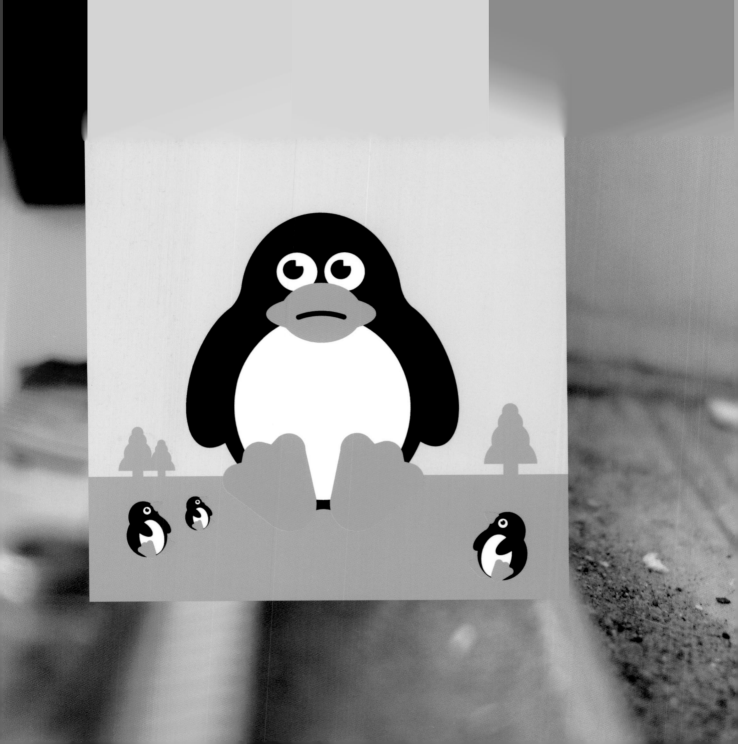

Brook Lorntson

Our last Open Space (a Speak Up traveling journal) participant, Brook has little tolerance for in-game advertising. Using games as an escape medium from the visually saturated, advertiser-overloaded world is no longer a viable option.

SU: We didn't know penguins enjoyed forests. Why this setting?

BL: Being a giant isn't necessarily a positive thing. He knows he's different. He's "out of his element." Also, I wish those lovable penguins lived in the forest just outside of town.

SU: Do you know what happened to make this penguin so big?

BL: I like to think of him as the offspring of an improbable panda–penguin pairing.

SU: This is a funny depiction of penguins. How did you come up with it?

BL: Nothing tugs at a person's heartstrings like a big, sad penguin.

SU: After participating in Word It, do you feel some kind of connection to the rest of the participants? Why?

BL: Sure! It's the juxtaposition of many Word Its that make them compelling.

SU: What is your opinion, in a general sense, of the other submissions?

BL: The quality of the content is remarkable. Word It is a great opportunity for designers to show their wit.

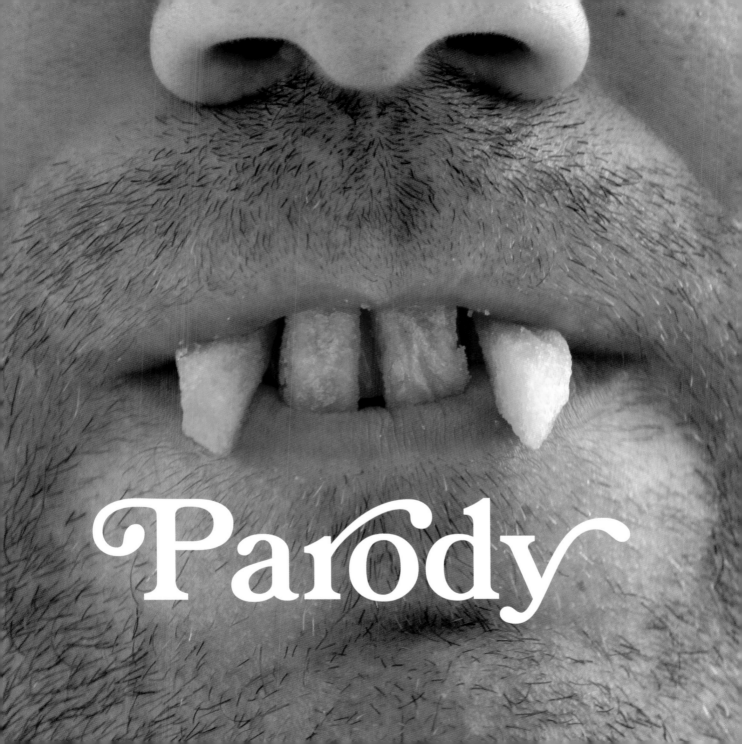

Date
April 2004

Total Word Its
37

Number of participants
25

Recurring themes
consumerism
Speak Up
beautiful people

Defaming branding
8

That which does not exist nor is true nor real nor possible, yet has the possibility of actually being, making it funny or sad or encouraging, simply by the imposition of two (or three or four or more) differing things that are not meant to be together (or are they?) and live in perfect harmony as a fiction of our sometimes twisted imagination and the relief that these exaggerated paradoxes and similes and contrasts and what-ifs are merely that and nothing more other than exercises in stretching the realms of decency, taste and all that is good and noble and accepted, threatening to mangle what we know and understand in a complicated knot of unbearable and delightful dualities through unapologetic irony and sarcasm and wit.

45
parody

Parody is the Word It for April.

Does this make me look fat?™

Michael Branigan

Sam Sherwood

Jason A. Tselentis

SU: How does this message relate to your own lifestyle?

JT: I haven't eaten McDonald's since the 1990s, and I eat at least 3-4 servings of green vegetables each day.

HELLO. I AM LOOKING FORWARD TO OUR NEW RELATIONSHIP.

SU: Was there a particular relationship that inspired this Word It? What kind of relationship does this speak to primarily?
MCM: No, not one in particular.

It speaks to simulated, successful relationships based on attempts that have failed, that have been tested and improved upon.

Michael Christian McCaddon

Michael Kovalchick

pmsn
Why do you keep bothering me?

SU: This is a unique pairing. How did you end up here?
MK: I was inspired by those darn hard Before & After category Wheel of Fortune rounds. The MSN/PMS combination seemed to be obvious at first and I had PMS—as in Pantone color—in mind. That is, until I realized that MSN had that Microsoft connection, so I had to throw in a good jab. It just took some quick research and a little time in Illustrator to make this logo parody.

Mr. Tharp

Rick Tharp was an inspiration for many designers around the world in the last few decades. Working from Los Gatos, CA, his reach was immeasurable, his humor incomparable, his wit enviable.

Mr. Tharp passed away in 2005, leaving a vast amount of Word Its in his path that have touched many of our readers.

SU: What made Mr. Tharp's sense of humor so unique?

Hank Richardson: Violeta Parra imagined, "Don't cry when the sun is gone, because the tears won't let you see the stars," and for as long as Rick Tharp could, that's how he lived his life. He had a way of looking at problems—even serious problems—as opportunities with thorns on them. He was always trying to figure out how to remove the thorns so no one got pricked. His peculiar acerbic wit and imagination enabled him to turn negatives into positives. His was the kind of wit that poked at you, too; as Rick questioned everything, he expected you to do the same. And because he felt an enormous sense of responsibility—to the world and its students—he instilled it in those around him.

Several years ago, one of the last times he visited me in Atlanta, we took a handful of Portfolio Center students out to dinner. During that meal, we learned of Saul Bass's death in California. Upon hearing the news, Rick ordered up a bottle of *special* California wine, and asked the waiter to pour it among the people at our table. He looked over at me, toasting Bass as the "best ever," and saying, "Hank, it is so scary now! We will soon be in charge." As he drank his wine, he cried—his tears but the eloquence of passion deeply felt. And after the tears, there appeared in his eyes that forever-Mr. Tharp sarcastic look, exciting the room as it could; and he cracked one of his caustic, cynical, wonderful jokes, and the night wore on to become one of my favorite memories.

Rick was a best gentleman, an honorable man, a sportsman, a challenge, a tease, a politician, a lover, a cynic, eccentric, a character, true and always searching. I miss him. I know that it pleases him, wherever he is, that I do.

Petrula Vrontikis: Tharp took his sense of humor very seriously—it was his native language. It was his way of expressing joy, pain, criticism, love… everything. Tharp's wit was sharp, because it was his sword and his shield; it was his means of negotiating life.

When pain overcame Tharp's sense of humor, he had nothing left to fight with.

Gunnar Swanson: His humor was largely based on letting things go the way they wanted. He didn't seem to push at stupid stuff to demonstrate his brilliance or to chastise us for our collective failings or such. He just let things flow.

Most improvisational humor groups are, despite a pretense to the contrary, well practiced. But more important than learning funny bits to throw into improv is to learn to embrace whatever comes up. If the other person on stage is playing a dentist who says he has to pound on your teeth with a hammer and pour lighter fluid into your nose and light it, you can't say "No. That would be horrible." That would kill the bit. You have to

respond as someone who believes whatever dumb crap is going on somehow makes sense.

When Rick dealt with catalog-ordered business cards with poodles and script type, he responded as someone who believed that it all made sense.

Frank C. Briggs: George Hamilton tells the story that he and George Peppard were walking on a Beach. This Kid recognizes them and asks each of them, "Sir, are you an Actor or a Movie Star?" George Peppard looks at the kid and in a very serious, stern voice says, "Son, I'm an Actor!!!!!" The kid looks at George Hamilton and asks the same question. George Hamilton replies, "Son, I'm a Movie Star." G. Hamilton's Response to the kid was the kind of Quick Wit that surmised Mr. Tharp's Career and Life. He was Genuine, Lovable, Approachable, and Candid, Ready to Appease and Accommodate anyone who knocked on his door.

Most important, Mr. Tharp never, ever took himself Seriously. That's what made Mr. Tharp Unique as a Husband, Father, Designer, Employer and First-Rate Prankster.

Given the same question and option of the above scenario:

Mr. Tharp was a First Class Designer, Second to None of his Generation. He lived the Life of a Design GOD. He was indeed a SUPERSTAR.

Ken Eklund:

1. Rick Tharp revered humor ("revered" may not be exactly the right word). He was passionate about it. It was a calling.

2. Humor stems from incongruity, and of course, designers are typically hired to remove incongruity. So of course, it tickled him no end to introduce, rather than remove, incongruity in his designs. (And get paid for it! Win awards! Aha ha ha ha!)

3. He was fascinated by the verbal-visual junction of the human brain. Neuroscientists study how our two brain halves communicate (or not); Mr. Tharp preferred to just play with them. (Word It is the perfect verbal-visual play-pen, of course.)

4. Like the best comedians, he could sense the question or the angle that people normally shy away from—and that's where he would go. I remember a clock he designed for a 1950s-style diner. In between the numbers on the clock face were the letters EATANDGETOUT—subliminally stating the Great Unspoken Truth of the diner experience at precisely the Vulnerable Moment (when you glance at the clock). Masterful.

5. There was heart to Mr. Tharp's work. Underneath the cleverness and the visual wit, there was a human heart, beating and feeling pride, joy, sorrow. Which is why we are so sorry to have lost him too soon.

PORTFOLIO FROM HELL

Green

Date
May 2004

Total Word Its
69

Number of participants
55

Recurring themes
complementary colors
envy
youth

W. Bush
1

Ah, the color of your eyes.

Like diving into the jungle, arms spread open, deep breaths in my lungs. Being swallowed by their intensity, by the mere strength of their existence. I let myself be pulled, taken in and engulfed in their sweetness. Mint and basil, kiwi and apples. Challenged by their fire. Peppers and limes. Flirted with by their humor. Edamame and zucchini, artichoke and asparagus. Amused by their playfulness. Peas, olives and grapes.

Ah, the color of your eyes. Perfection, just as Mother Nature intended them to be.

53
green

Green is the Word It for May.

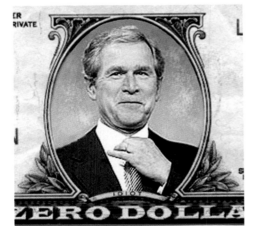

Peter Scherrer

Felix Sockwell

Jason A. Tselentis

Stephen Mockensturm

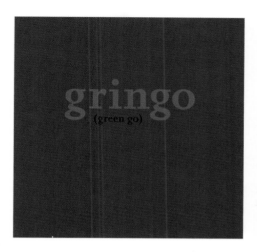

gringo

(green go)

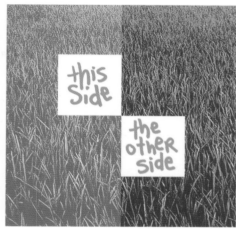

this
Side

the
other
side

Carmen Garcia

Joy Olivia Miller

Michael Christian
McGaddon

Steven Soshea

with
envy.

green

Oops

Date
June 2004

Total Word Its
61

Number of participants
48

Recurring themes
pregnancy
UPS
mistakes

Broken bones
2

Darling,

I left the cat in the oven and the baby in the fridge.

I vacuumed the ceiling and watered the carpet.

I scheduled your haircut at the deli and the manicurist for delivery.

I rinsed the pillows and ironed the dishes.

I folded the dog and groomed your sweater.

I washed your computer and powered up your slippers.

Don't miss me too much while I am gone.

Love,

B.

Oops is the Word It for June.

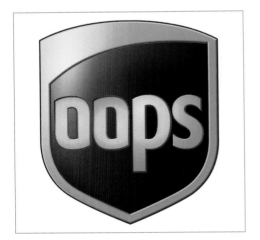

Bryony Gomez-Palacio

Marian Bantjes

Greg Scraper

Tom Futrell

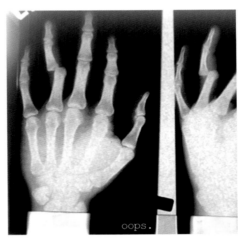

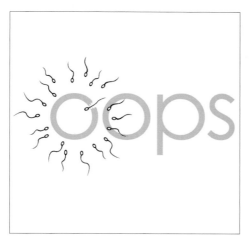

TJ Lomas

Armin Vit

Pedro Vit

Arturo Elenes

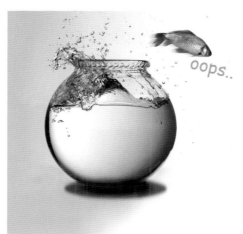

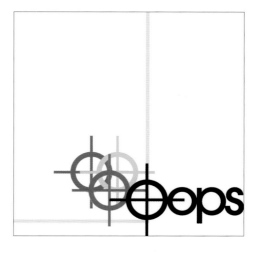

Brand
(ing)

Date
July 2004

Total Word Its
62

Number of participants
42

Recurring themes
recognizable logos
marlon brando
®, ™, and ©

Number of &s
3

A trademark
or distinctive name
identifying a product
or a manufacturer.
A product line
so identified.
A distinctive category,
a particular kind.
A mark indicating
identity or ownership,
burned on the hide of an animal
with a hot iron.
A mark burned
into the flesh of criminals.
A mark of
disgrace or notoriety;
a stigma.
To mark with
or as if with a hot iron.

To mark
to show ownership.
To mark
with disgrace
or infamy; stigmatize.
To impress firmly;
fix ineradicably.
To put
a distinctive mark
upon in any other way,
as with a stencil.
To show quality of contents,
name of manufacture.
A name given.
A recognizable kind.
Identification mark.
To indicate ownership.
As if it were branded on my mind.

Brand(ing) is the Word It for July.

Bryony Gomez-Palacio

Natalie Hodges

Nick Shinn

Armin Vit

Paul Kimball

Stephen Mockensturm

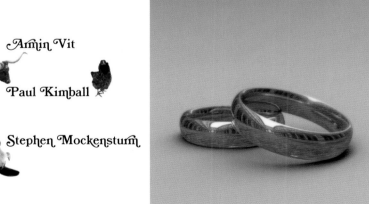

SU: Marriage as a brand? Or marriage as being branded? And why?

SM: I was interpreting "brand" as the mark one would find on certain cattle. When the word first came up, I thought about common societal marks that define certain institutions and human states. Granted, when we talk about brands at Speak Up, we are constantly reminded that the mark is just one piece. But I thought about the wedding band and the aspect of it that communicates, "I am held by someone." In that sense, one who brandishes a band is branded.

The illustration shows two rings because… well… one isn't much good without the other.

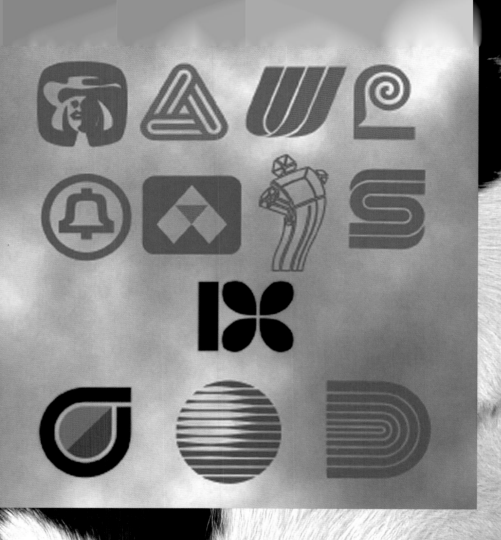

Frank C. Briggs

Frank C. Briggs, a.k.a. Design Maven, first joined Speak Up in July, 2003. To this date, he is the only participant to remain anonymous to the majority of readers, and is known for his particular writing style (both in use of words and visual panache).

SU: Do you have proof?
FB: The statement I was making, is that Saul Bass was undeniably a GOD in Identity and Design. The Word It was created shortly after Landor's redesign of Saul Bass's YWCA Identity. Thus, I substituted the Quaker Man (affectionately named Larry) for Saul Bass. I always thought Larry the Quaker Man was a Self Portrait of Saul Bass. The substitution of the Quaker Identity for the letter *S* was a Visual Pun.

SU: You idolize Saul Bass more than anyone we know. Can you tell us why?
FB: Tough Question. I love Paul Rand equally as much as I love Saul Bass. I love them because of the Totality of their Design Sphere and Capability. There are other Designers I Love but don't talk about as much as Bass and Rand. I love them because I grew up with their imagery in my home. When I transcended from being an Illustrator to a Designer, I didn't have to go outside of the Comfort Zone of my home to find inspiration as a Designer. There was the Poster in my home of the Lincoln Center 2nd International Film Festival, Designed by Saul Bass circa, 1963. Not to mention the Identity and Package Designs for Lawry's, DIXIE and Hunt-Wesson.

Whenever I mention Saul Bass or Paul Rand in conversation or online, it is my way of keeping their names ALIVE!!!!!!! It's the least I can do for two People whom I Love, who have given me so much, and who continue to inspire me.

SU: What did you have to do in order to produce your submission?
FB: The Word It Category was extremely Appropriate and Timely. I was fired up by the YWCA Identity. Ultimately inspired by a Branding Word It Created by Armin Vit, The Man With The Golden Arm and Felix Sockwell, The Texas Bad Ass.

I have an Extensive Database of Identity Work. Decided to create something Unique that I'd never seen before. A thought occurred to Create the Word It with all Saul Bass Identities. The Rest is History.

SU: What is your overall opinion of Word It?
FB: I absolutely Love Word It, and I'm ashamed I haven't contributed more. Paul Rand noted Good Ideas don't come in Bunches. It is a Credo to which I ascribe. I think Legendary Identity Designer Rick Tharp may have Proved the Theory had Chinks in its armor by submitting more Word Its for a single submission than anyone in the History of Word It. Certainly a Milestone in accomplishment. Mr. Tharp was definitely the unchallenged KING of Word It.

If I can just get my lil' sis Jenny Bass to make the above Word It the cover of the forthcoming Saul Bass Monogram, I'd be in Heaven.

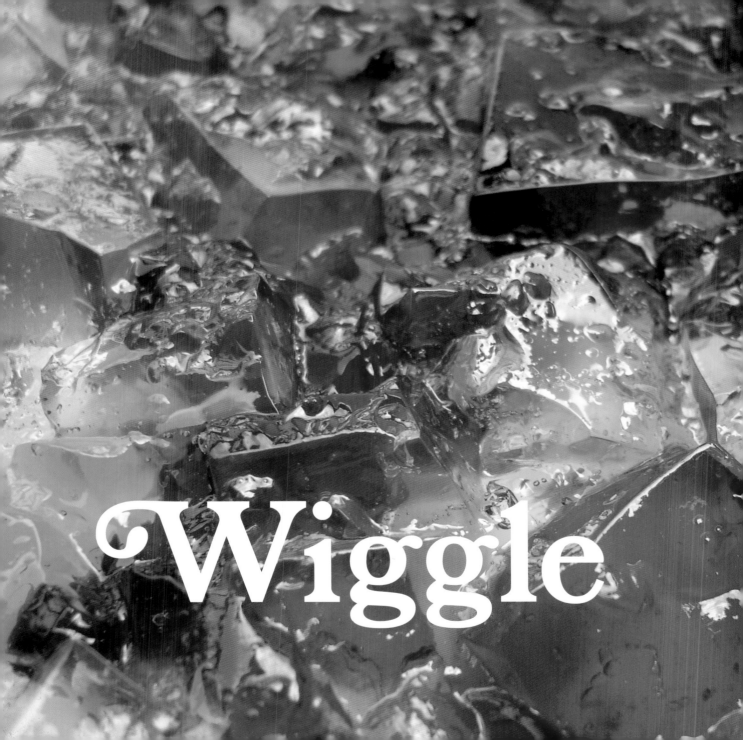

Date
August 2004

Total Word Its
56

Number of participants
46

Recurring themes
lines
insects
tushies

Animals
13

With the end of summer fast approaching, I figured it was time to let our hair run wild, let go of our worries, _____ our toes and hang out with a load of kids.

For this is the time to charge up the batteries and the heat reserves. It is no moment to hold back or stay behind, as each laugh and ray of sun will keep you focused on the tasks ahead.

Not sure why, not sure how—but following my end of summer mantra, I figured it best to jump into the water, swim with the fish and of course, _____ my behind in order to catch my young prince.

67
wiggle

Wiggle is the Word It for August.

Daniel Pagan

Gina McLaughlin

Mark Kingsley

Mr. Tharp

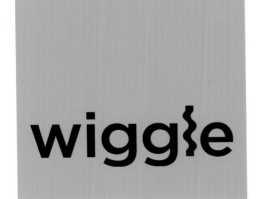

wiggle

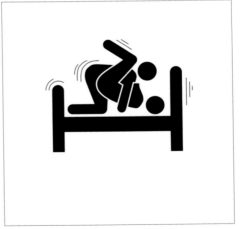

Step 1

Step 2
Repeat as desired

Peter Scherrer

Kevin McGuire

Marian Bantjes

Andy Weitzel

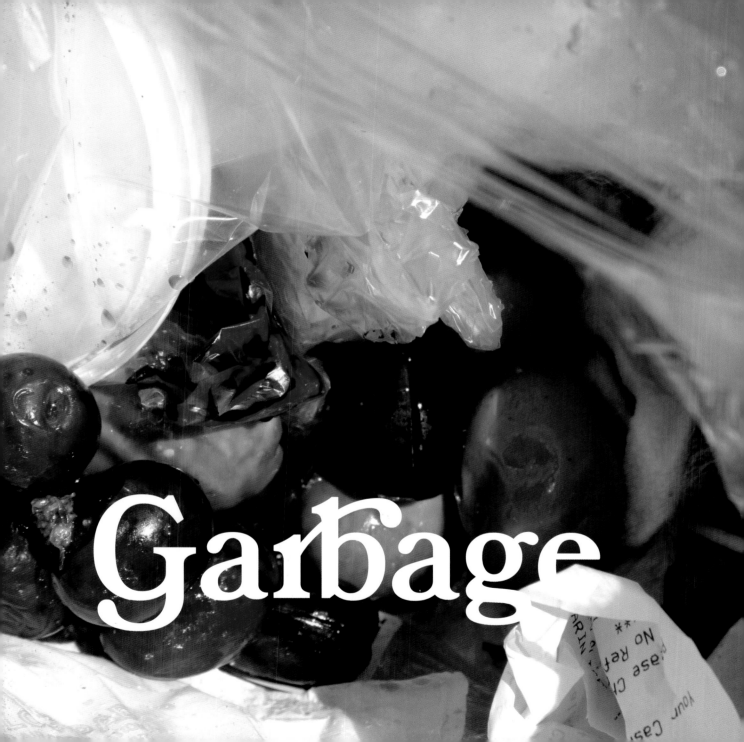

Date
September 2004

Total Word Its
56

Number of participants
47

Recurring themes
tv
food
typefaces

Vices
4

You leave it on the curb, you drag it around your desktop, you might use a quick command or ask somebody else to do it. Other times you will think you are surrounded by it or that this is all that you can create.

You know what I'm talking about. Garbage. It surrounds our best ideas, it gathers in the corners of the most beautiful rooms, it clutters our folders, and we love to send our kids out to the curb with it. It is a chore; it is a daily thing. Online, offline, whatever, garbage can be found on the ground, on a desk, on people's mouths and on a few brains around town.

71
garbage

Garbage is the Word It for September.

SU: What did you go through to come up with and execute this idea? And why the *f*?
DS: I used the *f* because I had used that letter in a design project—I guess it was still on my mind. Besides, it's a letter that both fits well and can be recognized when in the recycle bin.

I digitally composited the green signs onto a photo I took of the bins. I made the 3D "f" using Illustrator's Extrude & Bevel, and I used a photo of a rusty surface as mapped art.

Dave Stevens

Karen Huang

James Bogue

Can you make it
sexier
??? (sic)

FEAR!

sand

comic sans

courier

Joanne Green

Laura Pavelko

Sue Harley-Mills

SU: Were you aware that Oscar's eyes and brows had so much "equity"?

SHM: Absolutely. Oscar's mono brow is one of the most memorable in the business. It's certainly in my top three—alongside his fellow cast member Bert and Frida Kahlo. His mono brow nestles above, some would say, manic eyes. I beg to differ—Oscar was the first eco-warrior, a champion of the recycling movement. I think it's frustration we see here; he's just trying to get us to listen. A visionary, born before his time.

SU: Who's your favorite Sesame Street character?

SHM: Aloysius Snuffleupagus.

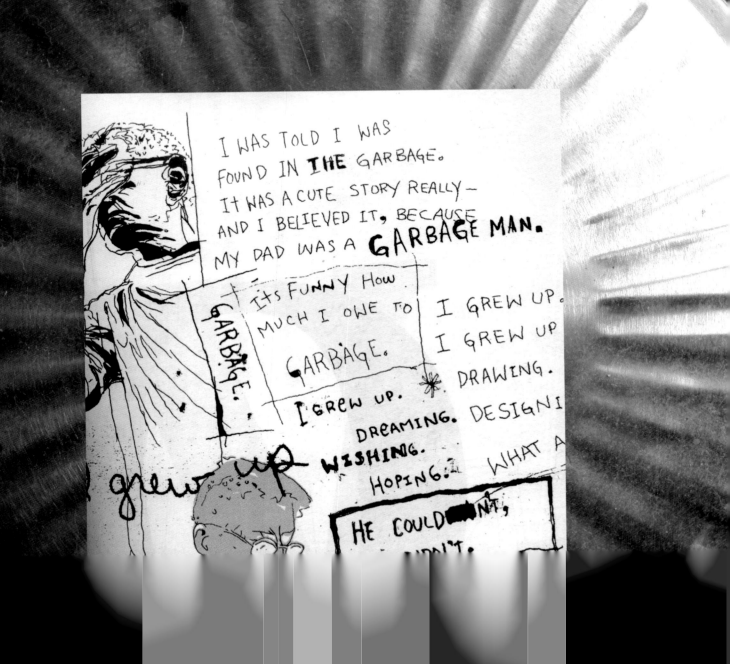

I WAS TOLD I WAS FOUND IN **THE** GARBAGE. IT WAS A CUTE STORY REALLY — AND I BELIEVED IT, BECAUSE MY DAD WAS A **GARBAGE MAN.**

GARBAGE.

ITS FUNNY HOW MUCH I OWE TO GARBAGE.

I GREW UP.

I GREW UP

I GREW UP. DRAWING.

DREAMING. DESIGNI

WISHING.

HOPING.

WHAT A

grew up

HE COULD NT,

Steve Carsella

Steve is a fan of comparing design to plumbing: "We're not really that far apart on the career food chain, and I think a more 'blue collar' approach/thinking and less hyper-theory in this field would do it a lot more good…"

SU: What was your inspiration for this idea?
SC: My dad. He was a New York City Sanitation worker for 35 years.

SU: What can you tell us about your execution process?
SC: This piece was solely from the gut. Totally intuitive and visceral. I used pen, ink, paper; it was more art than design. But art informed by my design learning. There is a companion piece (see right) that describes a true life experience with my dad that has a benign supernatural bent to it…

SU: Would you say that this is a particular style that defines you? Or was this out of your comfort zone?
SC: Totally OUT of my comfort zone! That's what made this so special to me.

SU: When you discover the next Word It announcement, what is your usual reaction?
SC: It varies from inspiring to frustrating! But they always elicit a strong reaction! Invariably, I spend many moments pondering what I'd do, often sketching and doodling my version…

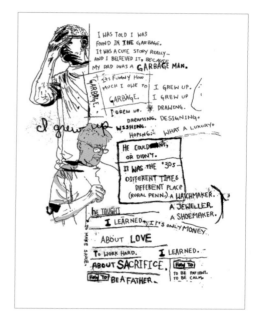

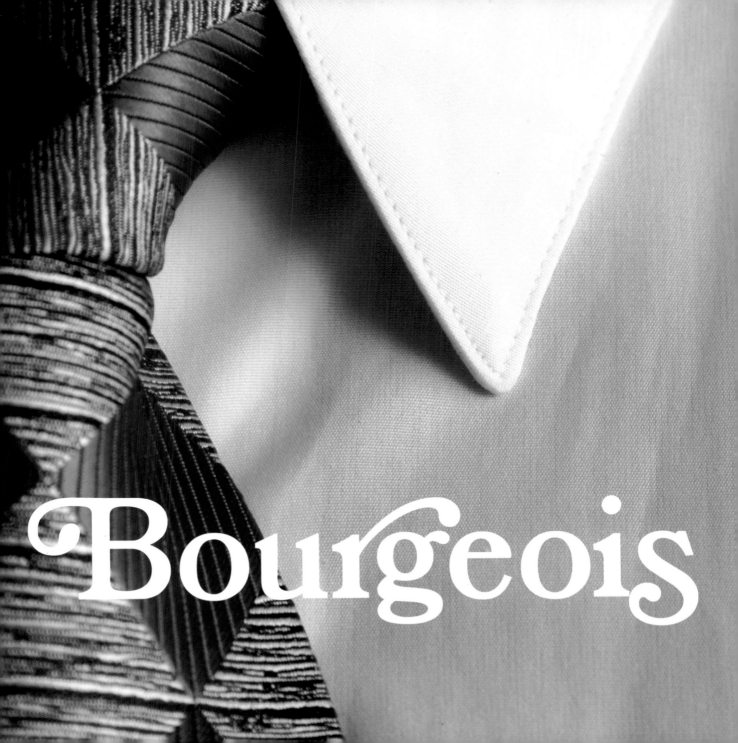

Date
October 2004

Total Word Its
49

Number of participants
44

Recurring themes
Apple
brands

Transportation devices
4

Accordant, anal, arriviste, average, Babbitt, Babitty, big-city man, boor, bounder, burgess, burgher, cad, campy, capitalist, churl, city dweller, city man, city slicker, clown, cockney, commoner, compulsive character, concordant, conformer, conformist, conventional, conventionalist, corresponding, everyman, exurbanite, formalist, formalistic, free enterprise, greedy, groundling, guttersnipe, harmonious, high-camp, homely, homespun, hooligan, ill-bred fellow, in accord, in keeping, in line, individualistic, John Smith, kitschy, kosher, little fellow, lout, low fellow, low-camp, materialistic, methodologist, middle American, middle-class type, model child, money-hungry, mucker, no great shakes, nonsocialistic, nouveau riche, oppidan, parrot, peasant, pedant, perfectionist, philistine, plastic, pleb, plebeian, precisian, precisianist, proletarian, propertied, public, regular, ribald, roturier, roughneck, rowdy, ruffian, run-of-the-mine, run-of-the-mill, sheep, square, straight, stuffy, suburban, teenybopper, townee, townsfolk, townspeople, traditionalist, unexceptional, unnoteworthy, unspectacular, upstart, uptight, urbanite, usual, vernacular, villager, vulgarian, working-class, yes-man, yokel.

77
bourgeois

Bourgeois is the Word It for October.

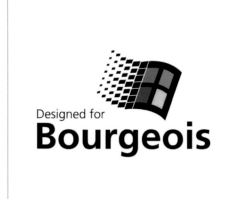

SU: Typographic humor is hard. How do you go about it?

KS: Good humor is hard. Bad humor is easy. I like bad humor. My typographic humor is bad humor. So bad that it's good. So good that it must've been easy. To me, at least. But seriously, ideas in typography have so many parallels to the human body and humanity itself. It's not that hard to find something funny when you think about what's in a typographer's lexicon. Typefaces are more than just a set of glyphs; typefaces have character—I try to exploit that.

Kosal Sen

Jason A. Tselentis

Christopher Palazzo

Designed for **Bourgeois**

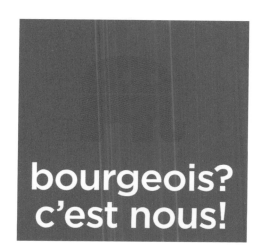

bourgeois?
c'est nous!

Mark Kingsley

Lisa Starace

"Can I get a grande skinny half-caf cappuccino wet, no whip?"

SU: Could you expand on your political statement? Why French?

MK: "Bourgeois" was the Word It right before the 2004 election and the month after the Republican National Convention was held in New York City. I was full of bile then. They came into my city and turned it upside down with such careless disregard for the residents, and with such fascist contempt for anyone who dared protest. Two years later, I'm still full of bile. What Bush and Cheney have done to this country is unspeakable.

As they contrived an excuse to invade Iraq, the Bush administration cynically went through the motions of amassing international support for the action, which France refused. Republican spin doctors then set up the French as a straw man, impeding the progress of democracy. The stupider effects of this media onslaught were restaurants refusing to serve French wine and the renaming of french fries as "freedom fries." "Bourgeois" is a French word which came from the Dutch "burgher" (city inhabitant). It eventually came to signify merchants and capitalists in the broad sense, materialist and aristocratic in the pejorative. Through their exploitation of the working class, Marx identified the bourgeois as the new ruling class. French is the sister language of English. So I propose that any American who makes a sarcastic remark about the French is, in part, insulting himself. This is what was in my heart as King Bush II and his royal court installed themselves in my beloved city during the fall of 2004.

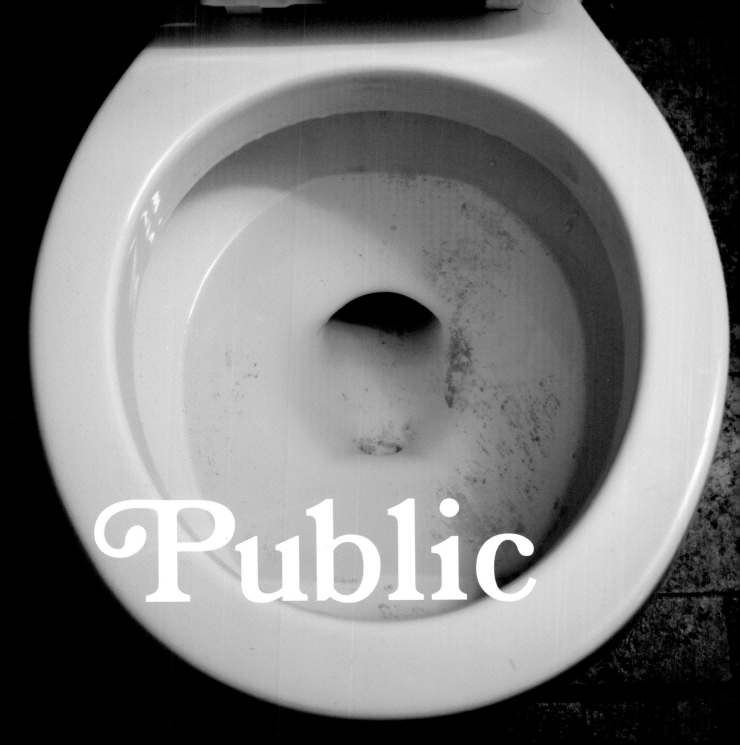

Public

Date
November 2004

Total Word Its
41

Number of participants
34

Recurring themes
privacy
politics
open space

Fences/gates
4

Your laughter. Your jokes. Your sense of humor.
My passion. My obsession. My curiosity.
Their conversation. Their fight. Their kiss.
Your insight. Your observation. Your opinion.
My solution. My interest. My words.
Their path. Their journey. Their destination.
Your hand. Your pen. Your disclosure.
My thought. My interpretation. My gut.
Their silence. Their protest. Their anger.
Your feeling. My feeling. Their feeling.

Public is the Word It for November.

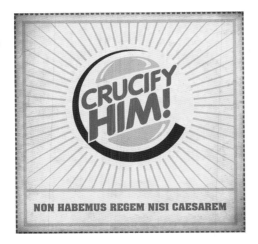

NON HABEMUS REGEM NISI CAESAREM

Stephen Mockensturm

Ng Jen Ling

James Bowman

SU: What was your thinking behind this submission? Why Burger King?

SM: I think I was reading about Pontius Pilate addressing the mob and he said something along the lines of: "Have it your way." That kicked the whole thing off. The Burger King logo is a public icon and I used it to convey a pretty well known public cry. In that way, this parody communicates the call of and the response to the people.

Furthermore, the crucifixion rendered Jesus as a piece of meat, so that tied in. And the Latin translates: "We have no king but Caesar." So you know… the king references and the meat and the BK motto all came together.

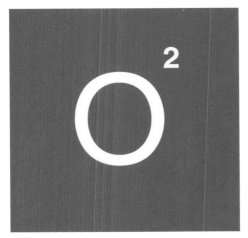

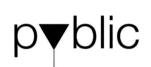

Public

Bryony Gomez-Palacio

Armin Vit

Karla Van Raden

SU: This is one of the things we love to catch others doing in public. Why do you think this is so?

KVR: The reason people like catching others picking their nose, scratching themselves or throwing up in public settings is because they are seen as "disgusting" acts.

How would you react if you were caught picking your nose? That is what is so funny about it. You caught someone doing something that is culturally embarrassing; embarrassing people is what is so fun. You can tease people and make it funny, or you can taunt others and make it embarrassing. It humanizes us all, as we are all flawed—it is the comedy of life.

Box

Date
December 2004

Total Word Its
55

Number of participants
46

Recurring themes
fox trot
cardboard
enclosure

Based on a logo
2

From there to here,
from here to there,
these things
are everywhere.

One box	Old box	Big box	My box
Two box	New box	Small box	Your box
Red box	Yellow box	Orange box	Checkered box
Green box	Purple box	Blue box	Polka-dotted box

From there to here,
from here to there,
sweet boxes
are everywhere.

Box is the Word It for December.

SU: What does this box hold?

MP: At the time I took the photo, the company I was working for was drastically changing its business model from providing a custom software solution to a series of pre-packaged solutions: out-of-the-box software. This image was one of a series I shot for an internal marketing campaign; the challenge (and tagline) was to "Think inside the box". The box theme was carried over into all sorts of activities and games to keep everyone focused on the project. I used a variation of this image with the headline "Love the Box".

So as you can see, the Word It was particularly well-timed…

Matthew Politano

Jesse Boyce

Marian Bantjes

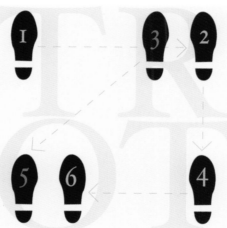

Jill Prestigiacomo

Shahla Nattagh

Michael Ziegenhagen

SU: What was your first experience with this particular dance like?

MZ: Well, I believe the fateful day was that of my middle school dance. I was wearing a hot new pair of Z. Cavariccis with matching rayon shirt. Being lanky and extremely uncoordinated at the time, I felt I should stick to a simple dance with predetermined moves. So, along with my trusty copy of "Dances for the Undancy People," I stepped onto the dance floor to impress the ladies. With my addition of traditional moves such as the Roger Rabbit and The Sprinkler, I wowed the ladies and all of the school. At the end of the dance, I was carried on the crowd's shoulders to my mother's waiting station wagon.

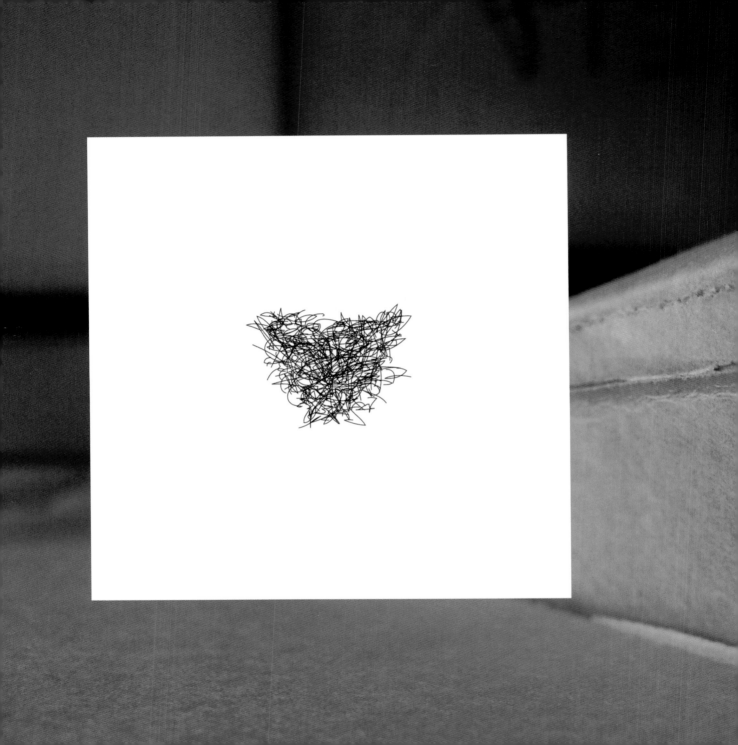

Michael Christian McCaddon

"Hardcore's about freedom of expression," Chris explains. A designer. A musician. A rocker at heart.

SU: What was your initial reaction to the word "box"?
MCM: Hot box. My mind had recently been adulterated by a marathon of 1980s T&A movies.

SU: Did you have any doubts about submitting this particular idea?
MCM: Not at all.

SU: Did you at any point think someone would be offended or upset?
MCM: Of course. But to my disappointment, I don't think anyone was. I did, however, receive e-mails from a few hurt individuals in response to my "empty" L.A. submission.

SU: How did you go about creating it?
MCM: A few minutes with the pen tool in Adobe Illustrator.

Date
January 2005

Total Word Its
73

Number of participants
64

Recurring themes
Sponge Bob
alcohol
population

Maps
3

Lots of food, cake and gifts, family visiting, bows and wrapping paper, nuts and dried fruits, chasing kids and catching decorations...

Every one of you, and everyone I know, is by now saturated and exhausted from last month. It is time to start your resolutions, catch up at work, clean up the mess and work on your Word It.

91
saturated

Saturated is the Word It for January.

Propane

C_3H_8

George Morgan

Jason A. Tselentis

Armin Vit

George Morgan

Jason A. Tselentis

Armin Vit

SU: This is our first chemistry-inspired Word It. How did you come up with the idea?

GM: It was the first thing that sprang to mind when I saw the Word It theme. It just happened. I was learning about saturated hydrocarbons at school at the time.

Being a bit more introspective about it, I found it quite interesting to present something so small and singular, in a theme that provoked responses mostly around "excess" (drenching etc.).

I should also add that my computer was broken at the time, so I just scanned the initial marker sketch at a friend's house and sent it in!

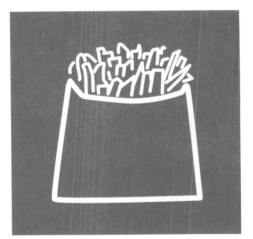

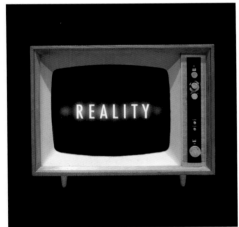

REALITY

Marian Bantjes

Anabel Lorenzo

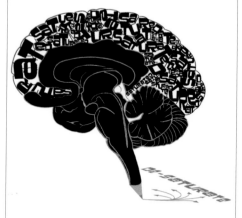

SU: Can you tell us how this image was created? And how it came about?

AL: This illustration shows that, through design, we have the ability to de-saturate the brain and help ideas flow.

It was created in Illustrator CS using the basic drawing tools and playing with the position of the type following the brain partitions.

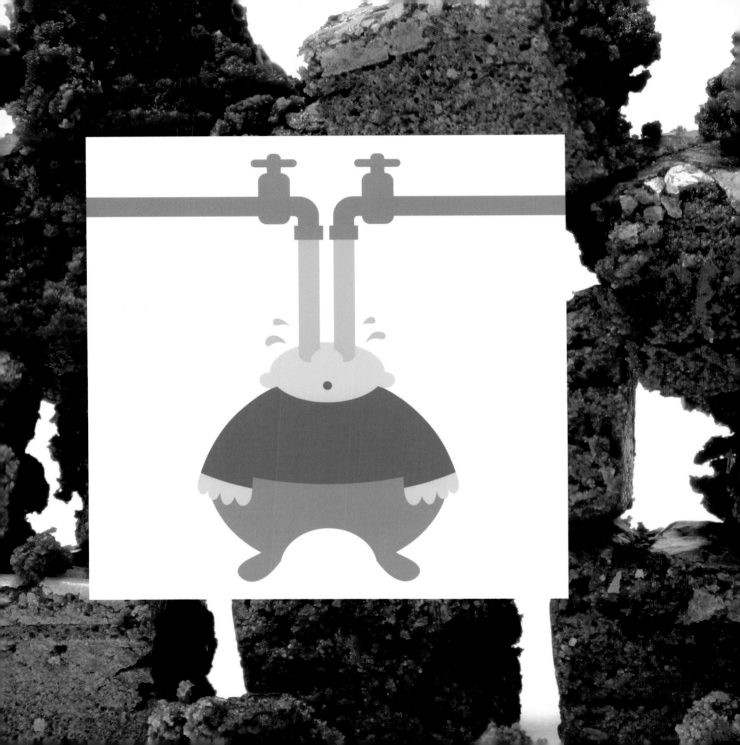

Tom Blackburn

Currently living in London, Tom recently completed a part-time course in physics and mathematics. Now, this has nothing to do with the fact that he plays the guitar or that he was born in the north of England—Huddersfield, to be precise.

SU: What was your process like when creating this Word It?
TB: It was pretty spontaneous—it just sort of popped into existence.

SU: How did you create the illustration?
TB: I did a quick pencil sketch on a scrap of paper, then cleaned up the shapes using Illustrator. I did the left side first, then reflected everything to make it symmetrical.

SU: Why water through the eyes, of all the possible orifices?
TB: Thinking about the word "saturated"—holding as much as can be absorbed—got me thinking about all the stuff we see all the time. We're constantly looking, always curious. Stuff keeps gushing into our consciousness, and yet we never seem to reach saturation.

SU: After participating in Word It, do you feel some kind of connection to the rest of the participants? Why?
TB: To be honest, I feel more of a connection to other Speak Up contributors because of the discussions on the site. Word It lets us all show off a bit.

SU: What is your opinion of the other entries?
TB: I was surprised at how many completely different meanings could be squeezed out of one word. I loved Marian's garish patterns, and the rubber ducks made me laugh.

DO NOT TOU[CH]

Mine

Date
February 2005

Total Word Its
66

Number of participants
57

Recurring themes
tantrums
monsters
relationships

Boom
2

7 Mines:

97
mine

1. Mine: A mineral excavation in the earth. The excavation site.

2. Mine: An ore or mineral deposit on the earth.

3. Mine: An abundant supply or source of something valuable.

4. Mine: An explosive detonated by contact, proximity or a time fuse.

5. Mine: A burrow or tunnel made by an insect.

6. Mine: To delve into and exploit something.

7. Mine: Used to indicate the one or ones belonging to me.

Mine is the Word It for February.

SU: There is a unique quality to your work. How do you go about creating it? What defines it?

AW: My work is an extension of my personality, thoughts and life experiences. I've interpreted things a certain way for my entire life, something that is hard to express with words—maybe that is why I draw instead of write.

I always start with concept development and thumbnails. When I'm satisfied with my idea, I develop a tighter rendering. I scan it and drop it into Adobe Illustrator. The final artwork is developed using the sketch as a template. Hand painted textures, layers of color and vector shapes make up the final illustration.

Amanda Woodward
SHUT YOUR TRAP

Ben Scott
STEP AWAY

Gunnar Swanson
GET YOU

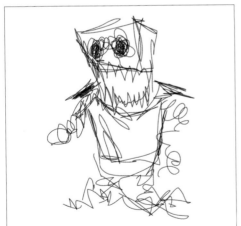

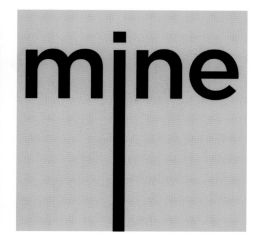

Christopher Simmons

Mark Kingsley
LEAVE ME ALONE

Eric Arvizu
THIS IS MINE

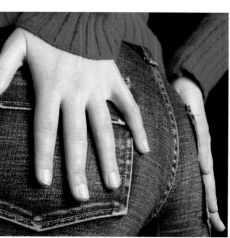

SU: How did you explain your concept to your model? How did the photo shoot go?

EA: Um, okay. You ask me what it was like explaining my concept to my model and how the photo shoot went. Actually, it was pretty simple because all I had to do was purchase a piece of stock photography and then crop it down to the most important area. I wish I could take more credit than that, but… I'm sure I was hunting for something else when this piece jumped out to me. Bojan Težak from iStock (I think) was the original photographer. All right, so this might not be the best answer, but it's the only one I got! Conceptually, I love the idea that we aren't supposed to possess one another, but we sure try hard to do just that.

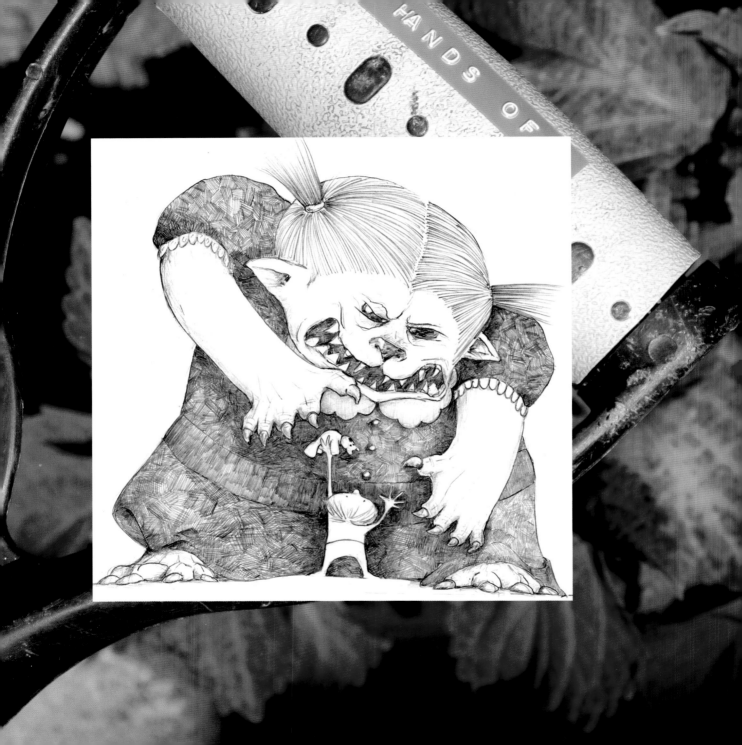

Jeff Gill

A transplanted American working, loving and making wondrous creations in the far reaches of the United Kingdom, Jeff is a frequent visitor on Speak Up. With his humor displayed through Word Its, and his quiet reasoning clear in his comments, distance is no issue for him.

SU: This is such a personal yet universal feeling that you captured in your illustration. Was this your first reaction to the word?
JG: Definitely one of the first.

SU: Did it come from first-hand experience with your kids?
JG: My daughter was two when I drew this. No one can say "mine" like a two-year-old! Or a seven-year-old (such as my son) for that matter. Or a grown-up.

Most of us never really stop saying "mine," do we?

SU: Was this your first sketch? Or did you go through several renditions of the same idea?
JG: It was my second or third sketch. I first tried to draw the figures from the side, but the angle didn't really capture the immenseness of the emotion.

SU: How large did you make the illustration? How long did it take you?
JG: The illustration isn't that big, about eight inches square. I spent two or three hours on it.

SU: Is this a style that defines you? Or did you step out of your comfort zone?
JG: It is a style that defined me when I was a teenager drawing every day and dreaming of becoming a political cartoonist. These days, most of my crafting time is spent at the computer. But I was pleased that, even though I hadn't been drawing regularly for a dozen years, when I sat down to do this illustration, my hand still knew how to work a pencil.

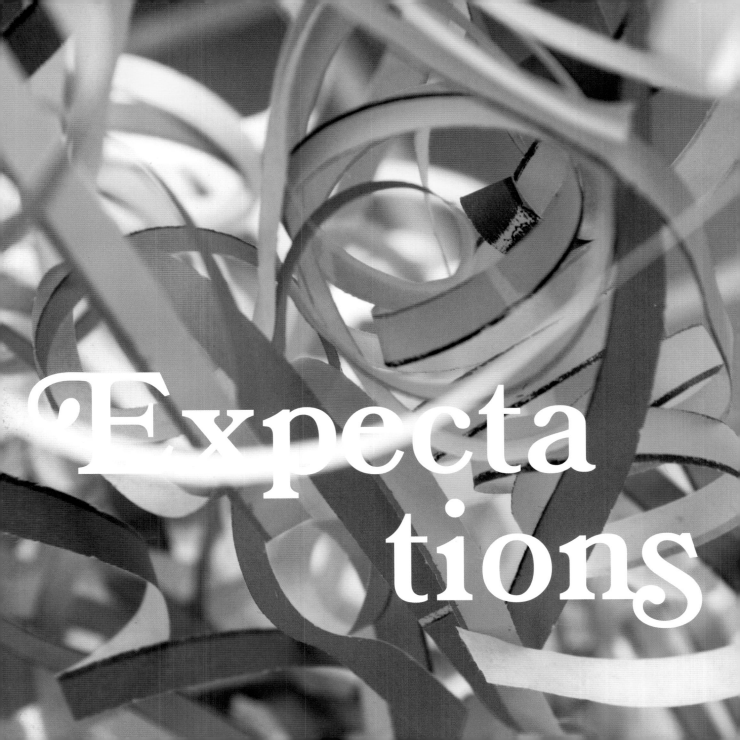

Date
March 2005

Total Word Its
45
Number of participants
38

Recurring themes
near future
history
Sports game
2

I wake up in the morning and I can't help myself. I think about it.

And so I decide to move on while tiptoeing around it, thinking I am not thinking about it, fooling myself into who knows what. But it is unavoidable, I have discovered, for it follows me during the day, from meeting to meeting, from design session to design session, even daring to interrupt my lunch break (and my Speak Up reading). Why can't it leave me alone? Why can't it let me be?

The best conclusion I have developed has to do with personality. Completely at fault, seeking and waiting, figuring things out and planning ahead, trying to read the future while developing expectations.

Expectations is the Word It for March.

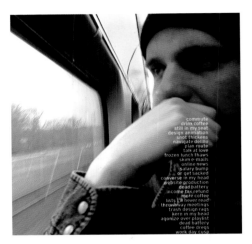

commute
drink coffee
still in my seat
design animation
snot thickens
navigate delillo
plan route
talk at love
frozen lunch thaws
skim e-mails
online news
salary bump
or get sacked
converse in my head
website production
dead battery
income tax refund
more coffee
lists I'll never read
throwaway meetings
trash design rags
kern in my head
agonize over playlist
dead battery
coffee dregs
work day cusp

Noel Childs

Tiffany Wardle

SU: Can you tell us about this moment?
NC: I recently moved my family fifty miles out of Chicago. We bought a house… the whole "suburban dream." Every day I ride the Metra train into the city: the commute is my time to be alone with my thoughts, visions and anxieties. It's also a daily transition—suburban sprawl to urban chaos, and back. When I'm not working, I'm staring out the window, marking the transition from grass to concrete.

On this day, I held my camera pointing toward myself with the subconscious thought of capturing a banal moment. It's a random automatic pseudo-self portrait of me thinking of what my day will be like.

SU: Sometimes we know it is coming, and others it is a complete surprise. What inspired this Word It?
TW: I think it came about because I was in a relationship where we were discussing marriage. I don't wear jewelry, but have dreamt of wearing a Tiffany setting for as long as I can remember. It is a romantic idea. I don't think I'm that materialistic, but is it so wrong for a girl to hope for a Tiffany turquoise box when asked for her hand in marriage?

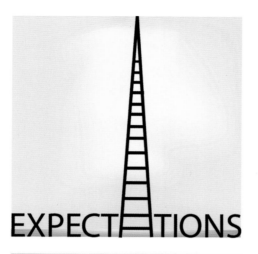

SU: What are your expectations?

UMD: Personally, I am determined to not expect anything from anybody. But in general, I expect the world to be a better place for every human being, animals and nature to live in happily ever after.

People have high expectations for me. I will try to climb that highest ladder of their expectations. And in fact, working to achieve these expectations for others makes life more meaningful.

SU: Can you ever say no? What are Spike's favorite things?

SS: As you can imagine, it's pretty hard to resist a cute face like that. Bratty and spoiled, he's also incredibly sweet and snuggly. Spike loves balls of all kinds, with a particular penchant for tennis balls, which we magically seem to find on walks, his favorite activity. He can be a "tough-guy" with other dogs, random cats, and occasional squirrels—but very quiet with horses. There's the all-important task of marking territory and sniffing enigmatic marks of those that have gone before. Then, maybe it's out to the backyard to take in some rays, while sniffing the breeze. All this followed by a hearty drink from his water bowl with significant dribbling of water all over the floor.

Unnikrishna Menon Damodaran

Steven Soshea

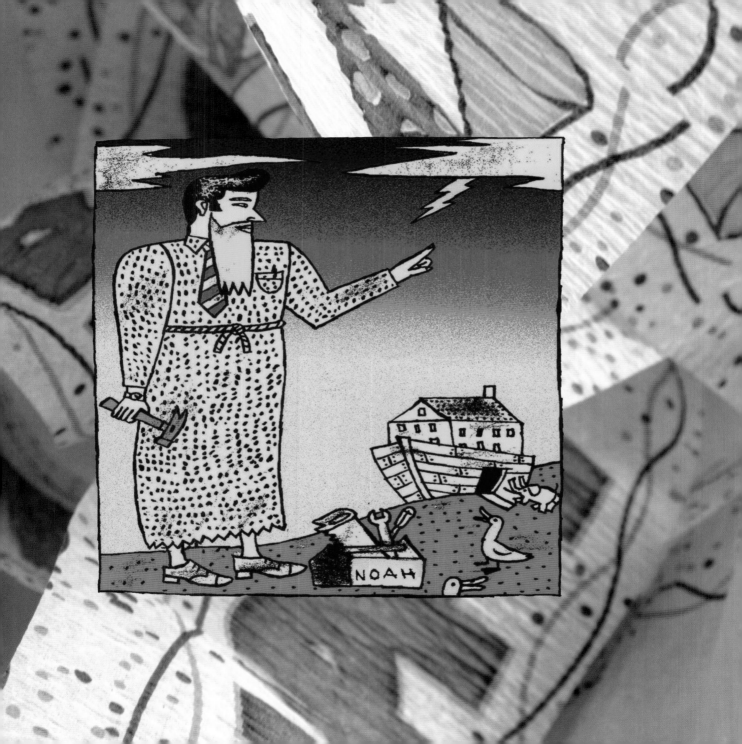

Mark Andresen

The designer of Not-Caslon, Mark describes: "It reels like drunken sailors on shore leave—the Black Sheep of the Caslon Family. It was meant as a joke, really, but I became serious about finishing it as I started to enjoy the odd gracefulness of it." This was 1995, when Emigre showed interest in its full development.

SU: So Noah wears a tie?
MA: It probably says so in the Bible—or *The DaVinci Code*, I think. Just one of those spiritual inspirations. Did you notice the (sockless) wing-tip shoes?

SU: You are one of our most constant contributors, so I have to ask: Why?
MA: I came across Speak Up around the fall of 2005, if I recall, and just read posts by designers to get the drift of what was being talked about outside Louisiana. I'm a conceptual illustrator, so I didn't interject my ideas very much—I do logos and all, but for Cajun bands and soul food restaurants, not giant corporations.

Then, as a Katrina evacuee in the days immediately following the disaster, I seemed to have a lot of time on my hands. We were homeless at first, taken in by friends. I wasn't even on my own computer, but I borrowed opportunities on other people's machines. Displacement required a diversion to get over the sadness of what was happening, to say the least. Speak Up offered me an opportunity to find some friendly voices online who helped me through that post-Katrina period. I am grateful to many of them who were marvelously generous and kind. Then it became a habit, like all things wicked or fun.

SU: What is your opinion of Word It? And the ongoing entries?
MA: It's fun. It's creative without client alterations or restraints. Also it brings me back over and over to see other people's solutions for the same word. The fact that it's not a contest, but an open design challenge is the best part.

SU: How would you describe your process?
MA: I don't know. We'd need to hire a psychic for that one. Pictures come to me… I surprise myself.

SU: How would you define your unique style?
MA: Oh, I don't have a style. This image you're referencing is kind of a goofy-looking folk art. (Louisiana sort of rubbed off on me, but it could have been anything.) There's always something about folk art and so-called outsider art that is refreshing to me: an unexpected detail or twist on the obvious. It's rebelliousness that flies in the face of slick media images, I guess.

I let the look of an image find itself, which is why my portfolio looks like twenty people designed it. It's all mine, and not derivative, so it has something in common. Not a style but a disparate strategy. Humor seems to be the best way to approach some ideas. It takes compassion to find humor in the difficult and absurd things in life and live through them…

Pleasure

Date
April 2005

Total Word Its
72

Number of participants
49

Recurring themes
greed
sex
the simple things

Squashing
2

From a Speak Up banter, or a child's clatter.

From a rainy afternoon, or a full moon.

From a juicy orange, or a strange homage.

From a lover's kiss, or pure bliss.

From a powerful machine, or a political theme.

From a short flight, or a serious fight.

From a single line, or a good wine.

From a single touch, or a hunch.

From a pica, or cheesy Formica.

From a star, or a neighborhood bar.

From a click, or a low kick.

From a dead end, or an online friend.

It is from these treasures

That with certain measures

I build up my pleasures...

Pleasure is the Word It for April.

*i love little pussy
her coat is so warm
and if i don't hurt her
she'll do me no harm
so i'll not pull her tail
nor drive her away
but pussy and i
very gently will play*

SU: What is it about the pussycat double-entendre that makes it so funny?

JG: You just can't beat the joy that comes from a bit of juvenile sexual innuendo. This one is all the more wonderful for the gentle language in which it is written.

Jeff Gill

Grace Wanzer

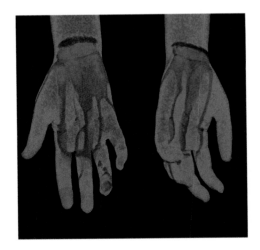

SU: This is a very powerful interpretation of the word. Can you describe your inspiration and process?

GW: My inspiration for this piece came from the idea that everyone gets pleasure from different things and that some people cut themselves for that reason. This is also about a different type of pleasure. It is about the pleasure of escaping the world around you and getting lost in it. Though the subject matter is serious, this piece was a lot of fun to make. I made a batch of fake blood and used my roommate as the model since she volunteered. After fooling around with it for a little while in Photoshop, this is what came out.

I love you, Mama.

Katie Sekelsky

Melanie M. Rodgers

Amanda Woodward

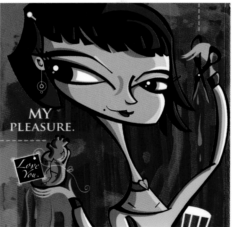

MY PLEASURE.

SU: I am sure many can identify with this pleasurable moment. Any person or situation in particular for you?

AW: Thankfully, this was not a personal situation. This piece was originally developed for a group show called "50 Ways to Leave Your Lover," put on at a local art gallery. Since the event situated around Valentine's Day, I opted to illustrate a devilish woman crafting valentine hearts— only instead of using cut paper, well…you get the picture. She seems very joyful in this activity, which seemed to suit the Speak Up Word It theme of "pleasure" perfectly.

SU: What was your Aha! moment like? Did you have to go out and buy a screw?

MS: Scanning my office, I was playing the word association game with objects. I noticed the screw in the electrical outlet and a moment later, I had something that made me smile. There were a couple of screws laying around, so I didn't have to go out and buy one, or unscrew anything.

Michael Surtees

Stephen Mockensturm

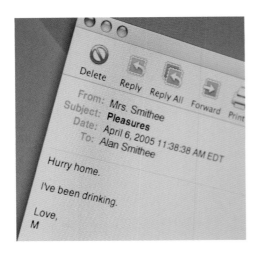

SU: Of all the names to choose for this execution, why Alan Smithee?

SM: Alan Smithee is a pseudonym used by Hollywood film directors who wish to be detached from a film for which they no longer want credit. I used that name as a clue—designers often being film buffs—to say, "Yes! It's a pseudonym!" (More creative than John Doe.) And generally, I wanted to use fake names to protect the innocent… not that I know anyone like this.

SU: Isn't 11:38 am too early to start drinking?

SM: Yeah, I guess—for normal people. But this person obviously has issues.

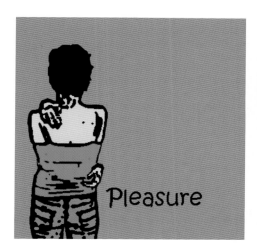

Ashley Cooney

Eric Arvizu

Jason A. Tselentis

SU: **List five things that instill this reaction in you.**
JT: A good piece of chocolate.
The Yankees winning a World Series.
Anything set in Franklin Gothic.
A good night's sleep.
When my students are prepared for a critique on time.

Nicholas Cane

Having traveled the entire length of I-95 north to south, Nick has been under police custody in three countries; he is broke and in debt. Yet, he somehow finds time to go to school, design to pay his bills and pose as Jesus and in a speedo (not at the same time, mind you).

SU: There is so much detail and texture to your Word It that at first glance might be missed. Was this intentional?
NC: Well, I didn't do this specifically to be missed; rather, it was completely involuntary.

I found myself drawn to the simplicity of a child's version of pleasure and used the silhouette. And me, not being too good with a paintbrush at the time, just kind of slopped it on. However, I always have known that really interesting pieces have a certain depth where the more you look and work for it, the more you'll get out of it.

SU: How did you achieve it?
NC: The background was pretty much a few fast, fat strokes with watercolors. I didn't worry about the actual brush strokes in it because it gave it all a more natural feel. You know… it didn't look Photoshopped. The kid was first a doodle in a notebook and then he grew to full size. I loaded up a brush with paint and went to town, again not caring for the integrity of the line because I didn't want it to look "graphic."

SU: Did you have different castles in mind when you drew this? The Taj-Mahal maybe?
NC: Ummmm. Kind of. Let's just say the final one painted wasn't exactly the one drawn out, due to lack of space. As for the Taj-Mahal, I'd rather destroy something better… like the Sphinx.

SU: Would you destroy someone else's sand castle?
NC: Absolutely. I'd probably guarantee you that I have… in the last six months.

Name

Date
May 2005

Total Word Its
71

Number of participants
52

Recurring themes
tunes
finger prints

Carved bananas
1

Adam. Eve. Apple. Serpent. Tree. Paradise. The First. Rib. Interpretation. **117**
name
Fresh. Punishment. Wife. Creation. Link. Origin. Passion. Earth.
Knowledge. Good. Company. Evil. Companion. Side. Garden. Forbidden.
Out. Sin. Bite. Curse. Sleep. Original. Name.

Name is the Word It for May.

Apr. 28 As we watched, **Patrick McMullen** began taking pictures of **Ethel, Todd Rundgren** & **Joe Jackson**. I later spoke w/Todd about living on **Horatio Street**. Great guy. He bought the drinks.

Apr. 29 Had lunch at **Tia Pol**. Spoke to **Sascha Lyon** (chef at **Balthazar, Pastis** & **Daniel**) about his new restaurant on **Gansevoort**—where **Hell** used to be. Friendly guy. Place sounds delicious.

1989 While out with friends; shook the hand of a photographer who shook the hand of his grandfather who, as a child, shook the hand of **Jesse James**. Great guy. Firm handshake.

Mark Kingsley

F3RRMK LOG

SU: Of all the stories you could have told, why did you choose this one?
MK: Most of the names in bold have greater recognition in Manhattan than anywhere else—something which I find obscurely hilarious. The Jesse James story was included because it deflates the other two. If you search hard enough, you're bound to have some sort of tenuous connection with any kind of celebrity.

By the way, Joe Jackson dresses beautifully but has clammy hands, Ethel released their second record, and I have yet to eat at Sascha.

SU: Several of your submissions involve bathroom-doormen. Why the attraction?
GS: I often riff on them because they are at once seemingly neutral and loaded with connotations. They are at once purely "man" and "woman" and all of the questions and arguments about modernity and Modern design, including assumptions of modern Western dress. They are officially sanctioned and ubiquitous. They supersede Neurath's isotypes as the attempt to be pure information while hanging doggedly to a wealth of cultural baggage. They scream "graphic design" while almost nobody notices them as graphic design. They are beautiful yet plain enough to manipulate easily. And they save me from riffing on happy faces.

SU: How did you go about executing this Word It?
CG: Name = ?
What reminds you of names, of people, of things, of animals, of anything? How do we make that connection between names and everything else?

When I read the Word It for the month and it was "name," the first thing that came to mind was the show "Name that Tune," which was incredibly popular when I was growing up. I instantly associated it with the very admired and nostalgic song of an early morning rooster.

Gunnar Swanson

AZ2CNWAIS

Carmen García

OIØBG6)4JU

Ryan Hurry

&39DGQ80C

SU: What was your first reaction to the word "name"? What inspired your Word Its? And finally, did you have any other ideas you didn't submit?

RH: My first reaction or thought was to Eminem's "My name is" song. However, I thought this was too obvious a solution for this particular word. Instead, I leaned toward another thought process where I thought it would be cool to take several common names—names we can all associate with—and illustrate them visually, slightly differently than the origin of the actual name.

I'm a big Batman guy, though I hate Peter Pan with a passion! Regardless, these two characters became my inspiration for this exercise.

I had several other characters, i.e., Superman, that I didn't submit because I thought two would be enough to get the point across.

If it doesn't come when you call it, why name it?

SU: A philosophical question indeed. What is your answer to this one?

TW: Personally, I am more "verbally oriented" than mathematical, thus I find naming objects (animate or inanimate) more useful than referring to them by number.

SU: What is your day-to-day relationship with Lorem Ipsum?

NS: To answer your question with the clarity it deserves, it's necessary simultaneously to consider dolor sit amet. According to C. Adipiscing [1970], "nonummy nibh euismod tincidunt." Yet I would maintain that magna aliquam erat volutpat. Which is not to say that minim veniam, nor that nostrud exerci. In short, aliquip ex ea commodo consequat.

Tom Whitmore

CBGRN!SMS

Nadav Savio

PARHOW5ZE

Department of the Treasury

U.S. Individual Inc

For the year Jan. 1–Dec. 31, 20

Your first name and initial
Lorem I.

If a joint return, spouse's fi

RETRIEVER
DIFFERENT NAME
SAME ANIMAL

ELEPHANT
DIFFERENT NAME
SAME ANIMAL

SALMON
DIFFERENT NAME
SAME ANIMAL

SU: What was your inspiration for this series?
AE: It was born from a connection between how we perceive certain objects, events and actions in relation to their given names. I've thought, "If I taught my three-year-old that an elephant was called a retriever, or a fish an elephant, would it really change the way he feels about the animal?" So rather than doing so and making for a very awkward kindergarten, I used Speak Up as an outlet.

SU: What is the story behind this valise?

JM: It's a closeup from a group of old suitcases that I found on the street—someone had cleared out a storage space and was throwing them all away. I found the tags with people's names and archaic zip code information—"New York 25 NY"—very interesting. They represented a story about the past which is only momentarily viewable and then gone forever. It's very alluring to imagine the people who used these suitcases, how their lives were different and where they are now.

While the cases and tags were beautiful, they were also deteriorated and a little disgusting up close. Not something you would want to use when flying.

SU: Have you ever used this bit of information to your advantage?

VG: Advantage? No. I have, however, leveraged it for a cheap laugh in my speaking engagements. Morphing my head onto a doorknob in my presentations seems to be humorous for those watching it. So, I guess I use it for bait as I fish for pity?

Jeremy Mickel

V/6LE$ EAXV

Von R. Glitschka

7J$B&QRXX!

All I knew was my name was Czech. One day I met a Czech designer and so I asked him what my name meant in Czech. He looked around the room walked over to a door and reached down grabbing it saying "Doorknob, Glitschka." So I have that going for me, which is nice.

Mac geek.

Kosal Sen

Kosal Sen, a.k.a. Sal Sen, is constantly on the hunt for word and image puns as they relate to branding, social, cultural or political aspects of everyday life.

SU: What process do you go through to create your illustrations?

KS: When I have a simple idea, its execution usually doesn't call for an elaborate process. Since I'm not an illustrator, I try to keep the execution as straightforward as possible, so the joke doesn't get lost. I first establish the setting with a photograph, place the characters right on top, and add the dialogue. Nothing fancy about it, it's all about the pun. On top of that, I might even sneak in little jokes for my own pleasure.

SU: Do you have specific typefaces you use again and again?

KS: The typeface I use always depends on the context. In the beginning of each project, I start with the classics. So in short, yes. After getting tired of it after several hours, I might search for a more specific face to suit the content. For this piece here, there wasn't anything I could think of with a bigger a-hole than an Avant Garde *a*. For the *g*, there's nothing cuter and pudgier than Cooper Black.

SU: Have you thought about syndication?

KS: Why not? It's just the motivation I need to continue making these. I got plenty more inside of me.

SU: What motivates you as a designer?

KS: Bad jokes and complication.

SU: What is your opinion of Word It and the ongoing entries?

KS: Word It lets loose the innocent and naughty side of the designer. The need for that creeps into every project, but in this case it is the final product. The ideas don't suffer through an elimination process. It's void of client obligations and typical restrictions. It's personal in the public eye of designers. Because of that, you can be as motivated as you want, or as lazy—which is why some are pure gems, and others I just don't understand.

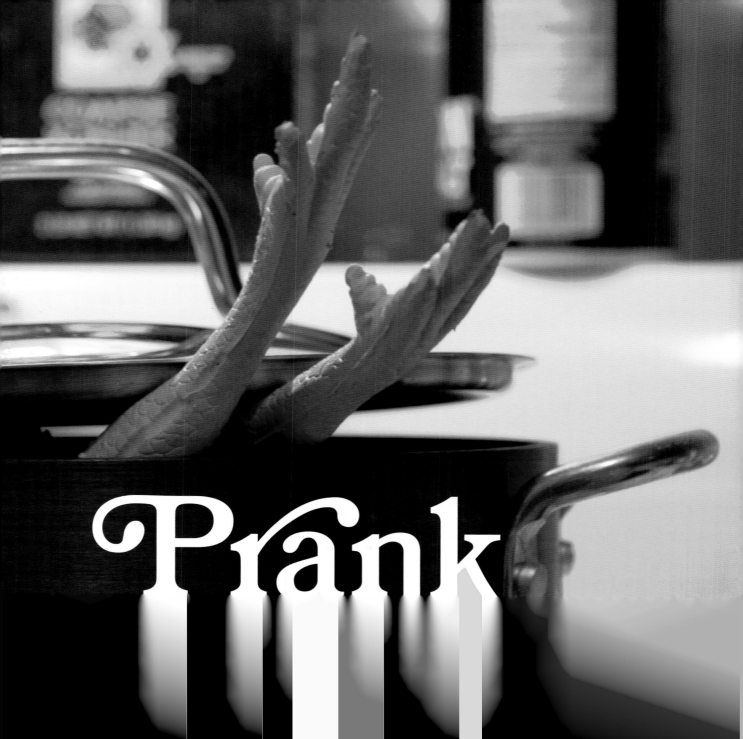

Date
June 2005

Total Word Its
50

Number of participants
37

Recurring themes
how-to instructions
banana peel

Whoopie cushions
2

Remember when you were, say, ten? That is what I was doing this weekend when my cousin was here for a visit. One day, who knows why, we sought vengeance on my brothers and decided to take matters into our own hands.

We went into their bedroom and infuriated them by mixing everything that could be mixed. Tapes were placed in the wrong boxes, dirty laundry folded and placed in the closet… you get the gist. Needless to say, our vengeance was (very) short lived.

Later, I recalled the mother of all pranks pulled on me. My little brother and his cute, skinny and awkward friend walked in with a sack. They told me they had found a kitten and were trying to figure what to do with it. They opened the sack so that I could take a look and go gaga, but what followed were screams and blows. You guessed it; there was no kitten. There was a six-foot-long boa constrictor (belonging to a cute, skinny and awkward little kid). I am extremely terrified of snakes…

Prank is the Word It for June.

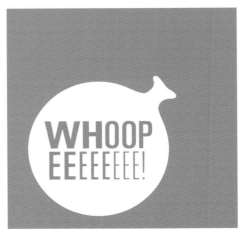

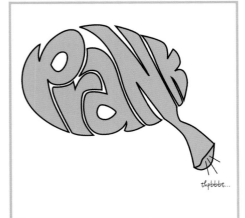

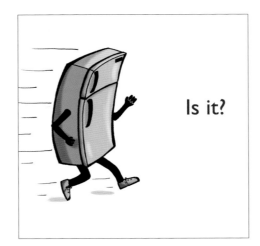

Is it?

867-5309

Don Hollis

Erin Ferree

Katie Sekelsky

James Bowman

Ptybk.

Rebecca Yoo

Alexea Rhodes

Ryan Hurry

Mike Winkelmann

PHONE PRANK# 79235029.84

LIFT UP THE PHONE RECIEVER AND PUT A BIT OF CLEAR TAPE OVER THE BUTTON UNDERNEATH, HOLDING IT DOWN (OBVIOUSLY DOESN'T WORK WITH CORDLESS PHONES). THAT WAY, WHEN THE PHONE RINGS AND THE VICTIM PICKS IT UP, THEY'LL BE STANDING WONDERING WHAT THE HELLS GOING ON AS TO WHY THE PHONE IS STILL RINGING.

GOD_PRANK #44: UGLY KIDS

In Today's News

› Helvetica and Frutiger Merger

› Vanderbyl and Bush Talk Certification

› Advertising Does Not Work

› Typography Is Really, Really Old

› New Apple iPhone Hits the Stores

› Microsoft DesignViz Gets 5 Stars

› Lucas to Direct Bodoni's Biography

› Pitt to Star in Fountainhead Remake

Jason A. Tselentis

(jay'sun - ay - cha' lend'is)
This Greek-Italian, raised
on comic books, science
fiction, calculus, classic
literature and film,
reached a milestone
event in the 1980s,
when he met Apple for
the first time.

SU: Were there any other headlines you opted not to include?
JT: These just came to me as I built the "prank." I knew that it had to speak to a design audience but also be timely, so I didn't have many options—except the ones you see here.

SU: When you discover the next Word It announcement, what is your usual reaction?
JT: Typically, it electrifies me—and that's not a facetious response. Ideas start popping into my head, and I get them onto paper as soon as possible; or, if I'm in front of the computer, I drag the mouse and click a lot until something comes together.

SU: To this date, have you been stumped by a word? Have you been completely turned off by one?
JT: I can't say that I've been stumped, although I do find myself with so many ideas that I have the challenge of editing out the junk. If anything, I always get turned on by a Word It.

SU: As a constant participant, you keep things fresh by submitting different styles and solutions. How would you describe your creative process?
JT: I have fun appropriating, manipulating or satirizing everyday visual culture and turning it into a fresh take of the given word. Sometimes things are instantaneous, while at the extreme end I'll pine over an idea for maybe a day—or even a week if I feel things haven't been resolved. In the end, I try not to repeat myself.

SU: What is your opinion of Word It and the ongoing entries?
JT: Since I started doing it consistently, I really adore the challenge and like seeing what others submit. My fellow participants inspire me the most.

Date
July 2005

Total Word Its
42

Number of participants
35

Recurring themes
x

daring sports

Posed questions
2

Beyond black and white. Further still from gray.

133
extreme

It is the point of no return that is exploited every single day by all media, and many an individual. Of course, that point of no return is beginning to turn rather ridiculous if you ask me; but who am I to say and define when the extreme becomes laughable, mediocre or just plain stupid.

Extreme is the Word It for July.

Mark Andresen

Leigh Wells

SU: Cajun Baby has appeared a few times. Where does he come from? Where is he going?

MA: The boy depicted is Conrad from Texas, and he's autistic. I met his mother, Lorraine, when she contacted me out of the blue several years ago when she saw a poster I did (about teaching a child through play) at her son's therapy. The poster, she said, made her cry. Since I got her a copy of the poster, we have had a few conversations about her family, especially Conrad and autism. How she thinks that possible mercury in the local water supply might have caused it. How it robbed him of the fullness of life. She used to send me photos of him and his brother, Dustin, growing up. I offered to do a portrait of Conrad for her, and I did this one first, sitting and smiling. Then I did another—one a mother would like—which I completed and sent.

During this time, I would occasionally work for an agency called Bent Media—before Hurricane Katrina kicked our asses. We did all the Tabasco web graphics for McIlhenny Company out of Avery Island, Louisiana. I did the illustrations. Just for fun, during one of the down times, I put the picture of Conrad and his blissful smile into a fake label: *Cajun Baby Hot Sauce*. Everyone seemed to like the deliriously happy Cajun baby. That's how it came into being.

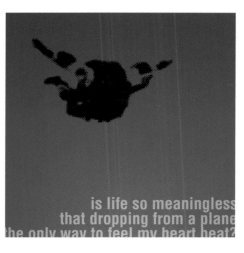

is life so meaningless
that dropping from a plane
the only way to feel my heart beat?

NO, SERIOUSLY!

Mike Winkelmann

Justin Watkins

SU: Do you think people tend to exaggerate?
MW: Yes, I think it is human nature to try to make things sound more interesting than they really are. I think this is even more true from an advertising perspective. Lately, we have been so inundated by "extreme" brands that something claiming to be "extreme" is so cliché. Now it has become more of a joke. People are so desensitized to "extreme-ness" that it is becoming harder to convince audiences that something is indeed "extreme."

Short Answer: Yes, I think it is human nature to try to make things sound more interesting than they really are.

Shorter Answer: YES!!!!!!!!!!!!!!

SU: What is the most extreme situation you have placed yourself in?
JW: It's intriguing to witness people put themselves through death-defying feats in order to get their adrenaline flowing. I think every person performs daring acts to their own degree—some sky-dive like it's not a big deal, while others get their blood pumping just driving 4 MPH over the limit. As for me, you won't catch me jumping from planes or even waiting in line to ride the latest roller coaster. However, Mountain Dew commercials do feature one of my pastimes: mountain biking. It's good to know that I'm not a complete pansy, and I'm winning cool points every time I strap on my brain-bucket and hit the trails.

John Foley

John learned early in his career to sign humbly and avoid flourishes in his writing when receiving POs from vendors—this after agreeing to print IR£7,000.00 post-it pads when he intended to produce IR£70.00. Needless to say, he ate cold beans from a tin for two years.

SU: What was your inspiration for this Word It?

JF: This was my first ever Word It submission, and looking back, it was the one that involved the least effort on the inspiration front. Everyone has their own personal limits, their extremes. Mine (along with, I suspect, the vast majority of Word It viewers) stop well short of coprophagia.

SU: How did you go about creating it?

JF: I started with some quick ballpoint sketches on a scrap of paper to establish the concept, then did a vector drawing using Macromedia Freehand—I borrowed the fork vector from a logo which I had recently designed and played with the color and composition. When I was happy, I brought it to Photoshop to add shading and generate the file for submission.

SU: What is Word It to you? A break in your day? A quick little exercise? A laugh during lunchtime?

JF: All of the above. Plus a chance to do something pure and simple with skills and interests that are normally employed on commercial projects that are anything but.

SU: What is your overall opinion of the other entries?

JF: The standard of work covers a broad spectrum, which I think is one of the really good things about Word It insofar as it keeps it accessible and open to all. I am always surprised at how little duplication occurs—it's inspiring to see so many different responses to the same challenge in one place. It clearly demonstrates that with any design or concept, there are always other possibilities. That said, I feel that a tighter limit on the amount of contributions allowed per word would encourage self-editing, which is sometimes not in evidence.

SU: Why do you think a lot of people are participating in Word It?

JF: Word It offers designers a chance to flex their conceptual muscles without the usual client constraints—its editing policy encourages anyone to get involved. Also, I think it is very popular simply because it offers the chance to indulge in a bit of harmless fun, which rewards a creative person on two levels—in the development/ execution of their idea and in the thrill of seeing it published.

Hot

Date
August 2005

Total Word Its
59

Number of participants
35

Recurring themes
red and yellow
sexy
heat sources

Partial state of undress
6

(In every sense of the word, of course)

Sizzling eggs

Burning pegs

Blistering soles

Searing floors

Scorching death

Stifling breath

Muggy room

Fiery doom

Intense horizon

Baking zonation

Fervent panting

Ardent hesitating

Smoldering perception

Warm inception

Hot SpeakerUppers

Very, very hot SpeakerUppers

Hot is the Word It for August.

Anabel Lorenzo

Lauri Gombest

Matthew Rodgers

Ryan Hurry

"Bestine…"

"Pardon?"

"Bestine. I used Bestine…"

Paris Hilton
is a haughty

Todd Davis

Mark Kingsley

Ryan Hurry

Leigh Wells

Hot Potato

Woodie Anderson

Woodie believes that "what separates Design from Art is the assignment and the interjection of a client into the process." And that process? Well, it is very organic, more like a spider-web brainstorm map, with lots of thoughts and feelings coming together in a sort-of Big Bang of design.

SU: You are a sporadic, yet recurring participant of Word It. What keeps you coming back?

WA: I enjoy Word It both as a concept and as a community. My participation is based more than anything else on my own time constraints. I leave the word on my desk and jot my random thoughts about it through the month, as they strike me. Often, I'll have a list covered in doodles and never actually find time to create and submit anything—I like the feel of it rolling around in my head; it's a nice energy. Visiting as new ideas are posted is gratifying, even if I didn't post myself. I still feel like I'm participating in the brainstorm session.

SU: What leads you to choose one word over another?

WA: It's more of a workload situation than an attraction to certain words. Some words are so charged, it's hard to imagine being dry. Regret is one that really struck me—I have concepts for it haunting me even now.

SU: If you could improve Word It, what would you do?

WA: I'd say it'd be nice to post and see comments on each design, but I can see that leading to flaming and trolls. It's kinda nice now that all who post are equal.

SU: Somehow we picture you doodling this, leisurely, while talking on the phone... are we anywhere close?

WA: Exactly right. It was such a silly, humble idea really, that I felt the presentation worked. The post-it pad serves as a frame of reference, I guess.

SU: What do you think would happen to a potato left in the sun for a long time?

WA: Is it like a carb deferred?

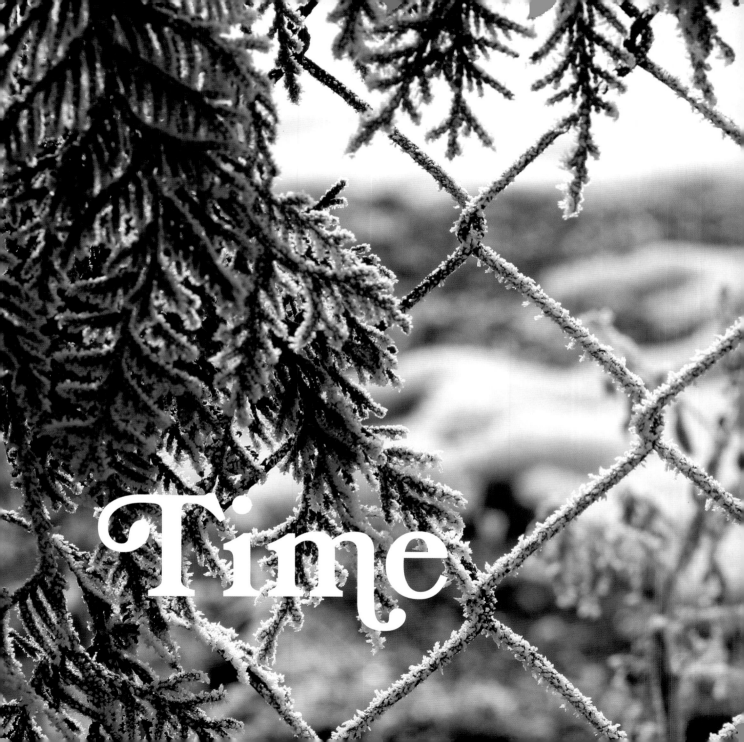

Time

Date
September 2005

Total Word Its
104
Number of participants
59
Recurring themes
expiration
seconds
Time magazine
2

145
time

Talking to people early in the morning late at night hello hello you again what can I do for you this beautiful morning minutes passing time flies when you are having fun tick tock tick tock I'm not having fun tick tock tick tock the phone ring ring ringing and ringing every day Monday or Sunday not you not me not my neighbor and least of all a friend calling chatting nothing important who cares what's up the usual coming and going home office office home dinner and something cinnamon my mouth and a vanilla taste milkshake and friends walk around and around like a dog in a pen circle circle ride the merry-go-round popcorn and clowns fourth grade carnival yellow balloons lost in the house music playing learn to play the piano listening carefully pay attention one two one two one two up and down memory lane hand in hand falling off a bike swimming in the river sing along patty pats and mud pies pillow fights the birds and the bees wonderment exploring testing how far you dare purple passion exit spinning door tip tap tip tap tip close your eyes breathe in breathe out let your body relax breathe in let your mind wander around and around like the merry-go-round.

Time is the Word It for September.

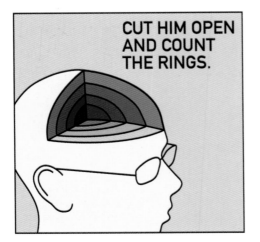

SU: Wouldn't it be great if we could measure maturity like this? Anyway, how did you create this illustration?

JH: I've been hooked on vector art since the first time I used Illustrator about thirteen years ago. For this illustration, I drew a contour outline of my own head, and sketched the glasses over the top to provide some spatial relativity. The "rings" inside the head were simple to draw, using the framework that vector art provides.

Jeffrey J. Hahn

Candy Rudolf

John Foley

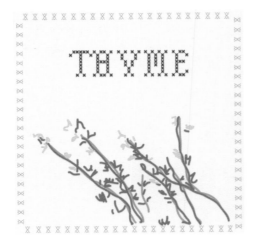

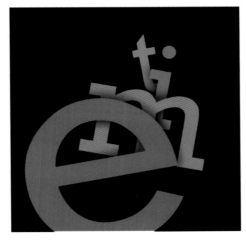

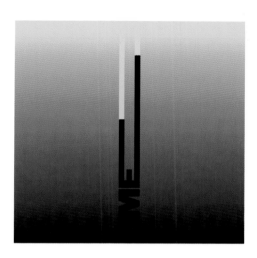

SU: How did this Word It come about?
NS: I think that the word "time" has begun to take on this meaning for me. I start to notice, more often than I would care to, that time is escaping. It slips away no matter how much I try to hang onto it; it is a finite matter. I live longer but I'll live less; yes, maybe that's it. I believe that this vertical time must be me.

Nacho Serrano

Sarah Koz

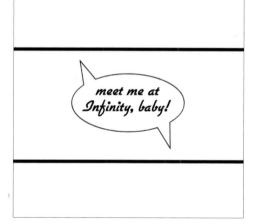

SU: What was your Aha! moment like?
SK: Parallel lines meet at infinity, and that transcends time. It was the first thought that came to my head.

SU: How did you create this Word It and its multiple illustrations?

SM: These illustrations are from a project in which I rendered the same subject—a cup and saucer—once a day, for 99 days. Each day, I tried a different medium and perhaps a different "pose" for the subject.* The marking off of days and the act of setting aside a part of each day for the drawing speaks to the subject of "time."

Stephen Mockensturm

David Werner

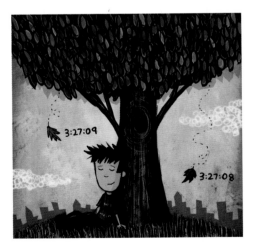

SU: Rarely is one able to perceive such peacefulness in an image related to time. What was your ultimate goal in creating this Word It?

DW: This image illustrates the idea that time is defined by how you personally spend it. It might be determined by the clock on a cell phone, the 9-to-5 workday, or when *American Idol* comes on TV. For this character, daydreaming under a tree with a city behind him, time is measured only by falling leaves. Although this might be seen as "wasting time" by some people, I feel fortunate to be part of the creative world, where imagination is part of my everyday job.

* If you want to see each cup in more detail, visit http://www.madmadmad.com/homework_SDM/99days/

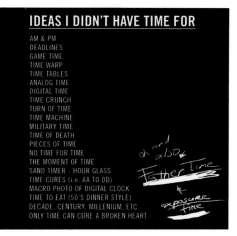

IDEAS I DIDN'T HAVE TIME FOR

AM & PM
DEADLINES
GAME TIME
TIME WARP
TIME TABLES
ANALOG TIME
DIGITAL TIME
TIME CRUNCH
TURN OF TIME
TIME MACHINE
MILITARY TIME
TIME OF DEATH
PIECES OF TIME
NO TIME FOR TIME
THE MOMENT OF TIME
SAND TIMER - HOUR GLASS
TIME CURES (i.e. AA TO DD)
MACRO PHOTO OF DIGITAL CLOCK
TIME TO EAT (50'S DINNER STYLE)
DECADE, CENTURY, MILLENIUM, ETC.
ONLY TIME CAN CURE A BROKEN HEART

oh and also Father Time & exposure time

24 HOURS IN A DAY

8 hours a day for sleeping
8 hours a day for work or school
2 hours a day for eating all 3 meals
1 hour a day for preparing all 3 meals
1 hour a day to exercise
1 hour a day for driving
1 hour a day for cleaning up
(dishes, clothes, yard, etc.)
1 hour a day for personal development
(reading, studying, drawing, etc.)
30 minutes a day for getting ready
(showering, dressing, grooming, etc.)
10 minutes a day for your teeth
10 minutes a day for using the bathroom
10 minutes a day for ME

Ryan Hurry

Juna Duncan

SU: Having spared the time to come up with this list, would you reconsider your time allocation for some of these ideas?
RH: Haha! Yes, definitely! I would love to take the time to go back in time and create some more time! Hahaha!

SU: Is this an accurate representation of your own 24 hours? How did you go about the calculations?
JD: This is not an accurate representation of my own 24 hours. I would love to get 8 hours of sleep a day. I thought of this one day after visiting the dentist. Like most people, I am always reminded of how important it is to floss. "It should only take you a few minutes a day," my dentist told me. "You only need to exercise 30 minutes a day." "Make sure to get 8 hours of sleep." These phrases got me thinking; do we have enough time in the day to do everything we are *supposed* to be doing? I wrote everything down and came up with the "perfect" 24 hours.

Joe Murphy

Joe has compiled a list of 63 things he wants to do—ranging from building a giant hedge maze in his front yard to hanging out in the New York Times' board room and designing at least one awesome poster. As of publication, he had completed 22 of the items and deemed them Worth Doing. 41 to go.

SU: Were you using a timer?
JM: Ha, heck no. No timer. I can count seconds pretty close (comes from my soccer ref days), but to make sure, I went back over the project and timed everything.

SU: What triggered this idea?
JM: I'm big on meta-information. Time *is* meta; time is information about whatever it is that's doing or been done. Focusing on the meta is often an excuse for avoiding the point, which is lame. However, here it is the point.

SU: Did you have fun during the execution?
JM: I take any excuse to write on index cards I can. Writing on index cards gives me release. I'm serious. I go through stacks of these things. It's fun.

SU: What words do you find most alluring?
JM: I'm an online journalist in my day job. Journalism is all about picking the right words (and photos and graphics) to describe something that's worth telling.

If you're asking about Word It words I am attracted to … well, I like verbs more than nouns and nouns more than adjectives; but if a word can be a verb and an adjective and a noun, then I like it the most.

If you want to know what words I enjoy overall, then I like words that demonstrate courage, that try something new, and that can illuminate the reader's world.

SU: After participating in Word It, do you feel some kind of connection to the rest of the participants? Why?
JM: Sure, I feel connected to the other people doing this. It doesn't come from participating, though—it comes from the "collective wince." When I see a submission that obviously uses a Photoshop filter, I *know* there are other designers out there who feel that filter pain, who remember when they used filters like that… and wince.

SU: What is your opinion, in a general sense, of the other submissions?
JM: Heck, there are some pieces that took creative and smart decisions; there are some pieces that took easy decisions. All took varying amounts of skill and resourcefulness. I like the ones that teach stuff about thinking visually, or illustration, or words, or photography, or stuff.

Date
October 2005

Total Word Its
83

Number of participants
56

Recurring themes
conversations
life

From the White House
4

Blah blah blah blah blah, blah blah. Blah blah blah blah blah blah blah blah blah blah blah blah. Blah blah blah blah blah, blah blah blah blah blah BLAH BLAH BLAH.

BLAH. BLAH. BLAH.

BLAH. Blah blah blah blah blah blah. Blah. Blah blah blah blah blah. Blah blah blah blah blah, blah blah blah blah, blah blah, blah blah, blah blah, blah blah, blah blah, blah blah!

Blah:
1. Blah blah blah.
2. Blah blah blah blah, blah blah blah.
3. Blah blah blah blah.

Blah blah, blah blah blah blah blah blah blah blah blah blah blah blah blah blah blah blah blah blah.

153
blah

Blah is the Word It for October.

BLAH ISN'T A REAL WORD SO I REFUSE TO TAKE PART IN THIS MONTH'S WORD IT.

SHAME ON YOU. I SUPPOSE NEXT MONTH THE WORD IS GONNA BE POOPYSTINKELWEEN?

Mike Winkelman

Daniel Pagan

Ben Scott

Michael Holdren

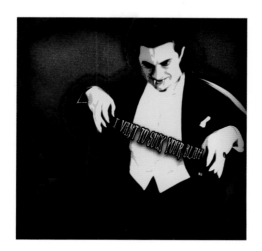

Grace Pierson

Mark Seggie

Roberto Christen

David Werner

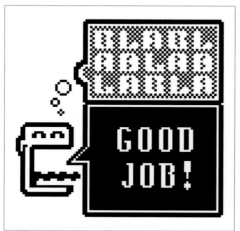

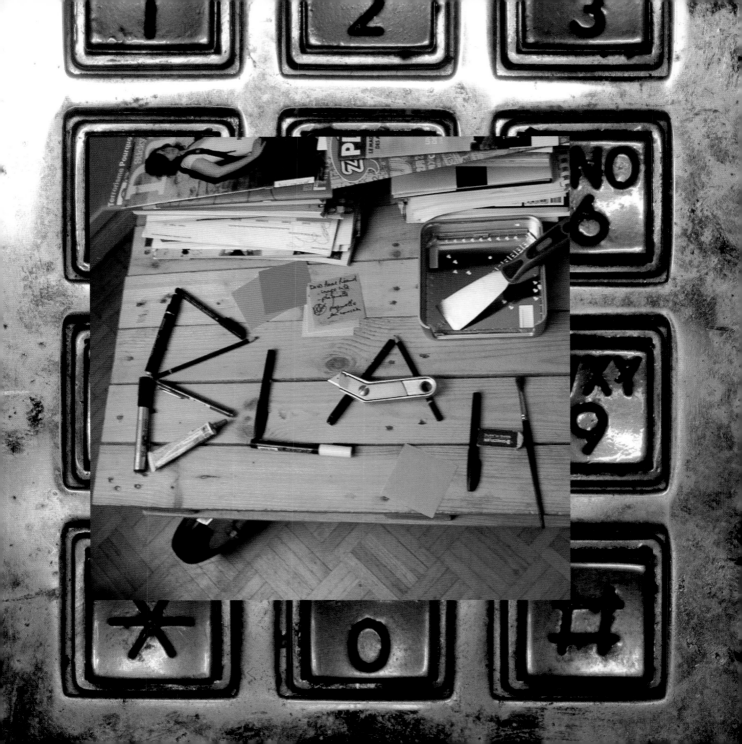

Philippe Gervaise

Philippe does not consider himself a photographer—just a "designer with a camera." His inexperience does not stop him from experimenting, as he enjoys capturing special moments through the lens.

SU: What led to the execution of this Word It?

PG: One late night, I was reading Speak Up when I noticed the Word It picture, a loud "blah." I felt it summed up pretty well the feelings I had about my work at that particular moment. I was struggling on a project full of bad design decisions and a gobbledygook brief. Later that night, as I sat on the sofa reviewing my to-do list, I thought "Yeah, more blah!"

SU: Once you had the idea, did you run around finding the perfect objects? Or did you let it all happen with what was at hand?

PG: The picture shows what was really in front of me. The coffee table, a paper reams pallet mounted on industrial wheels, the everyday mess… I just grabbed more pens, arranged them, and voila!

SU: What was the best part of the creative process? The worst?

PG: I'm afraid there was no real process involved. The best part was that the idea hit me in a matter of minutes; the worst is the embarrassing message "everything I create is blah-tantly meaningless."

SU: How did you first find Word It? What was that encounter like?

PG: I can't remember how I discovered Speak Up, but I really enjoy browsing the submitted pictures. I often think "Oh, I would never have imagined this!"

Never? And I'm supposed to be creative?

SU: What is your overall opinion of Word It?

PG: It is a very refreshing idea. As designers, we may sometimes lack motivation or inspiration. It's easy to start going round in circles. Word It is great to discover new takes on even the most ordinary word; it reminds us that another approach is always possible. I think it also highlights the cultural differences between the author and the viewer.

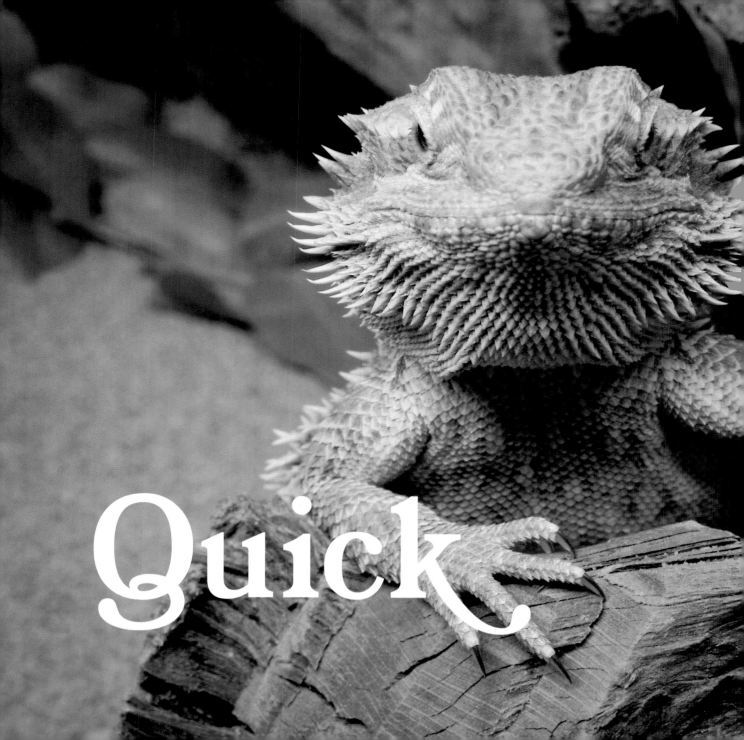

Quick

Date
November 2005

Total Word Its
76
Number of participants
54

Recurring themes
death
personalities
fast food

Little blue pills
1

Quick
Dick
Bring the brick

Quick
Brit
Raise the stick

Quick
Warrick
Take care of your nick

Quick
Rick
Empty the sink

Quick
Dominick
Be a prick

Quick
Nick
Will you be sick?

Quick
Vic
Won't you shriek?

Quick
Annick
Use the nonstick

Quick
Patrick
Submit your pick.

Quick is the Word It for November.

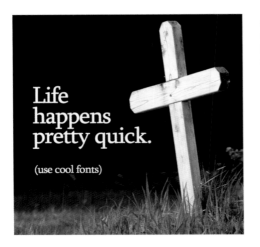

Life
happens
pretty quick.

(use cool fonts)

SU: Your sense of humor is rather unusual, can you tell us where it comes from?

MW: I think my sense of humor usually comes from a somewhat dark place. It seems like my imagination can quickly conjure up some pretty horrible scenarios, which a lot of the time I find to be very funny. My sense of humor is typically blunt and usually pretty crass.

Mike Winkelmann

Todd Davis

David Werner

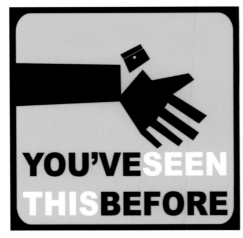

YOU'VE SEEN THIS BEFORE

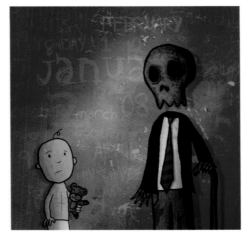

Alison Iven

Michael Dooley

Robb Smigielski

SU: Can you tell us about how you actually produced this Word It?

RS: I had recently been forcing myself to do more sketching in my design process and had been struggling to maintain the necessary focus. I always have big ideas in my head but labor with putting them down on paper in sketch format. I start off very detailed, and I quickly lose patience. Before I know it, I move on and never really finish the sketch. Which I guess is good enough, since the idea is on paper and I can reference that later. This Word It for "quick" was a manifestation of that process. You get the idea, even if I didn't have the patience to finish it.

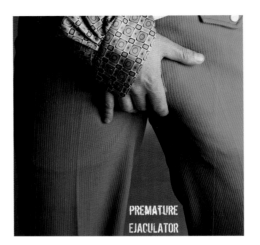

SU: Is there a story behind this solution? Where does it come from?
DW: I love participating in Word It, and I always try to come up with an idea that is different from everyone else, although that's not always the case. This one, I just knew it was a risky subject that others may not want to put out there, so I gritted my teeth and hit the send button on my e-mail!

Diane Witman

Jeffrey Garczewski

Lucien Frelin

SU: Can you tell us about the execution of this Word It?

JS: Well, I was in experimentation mode when this Word It was developed. It's an Adobe Illustrator vector drawing put in Photoshop and paint-brushed on—a technique I have played with a couple of times.

Jonah Stuart

Jobel Jose

SU: How did you come up with this idea? How did you go about the execution?

JJ: One of the first things that came to mind with the word "quick" was the bunny from Nestlé's Quick chocolate milk—I loved making this when I was a kid. Another thing I've always had a love for (perhaps borderline obsession) is celebrity gossip. I thought merging these two loves would make for a fun visual.

I did a Google search for vintage Nestlé Quik packaging and used that as the basis for the colors and type. I produced this using Adobe Illustrator.

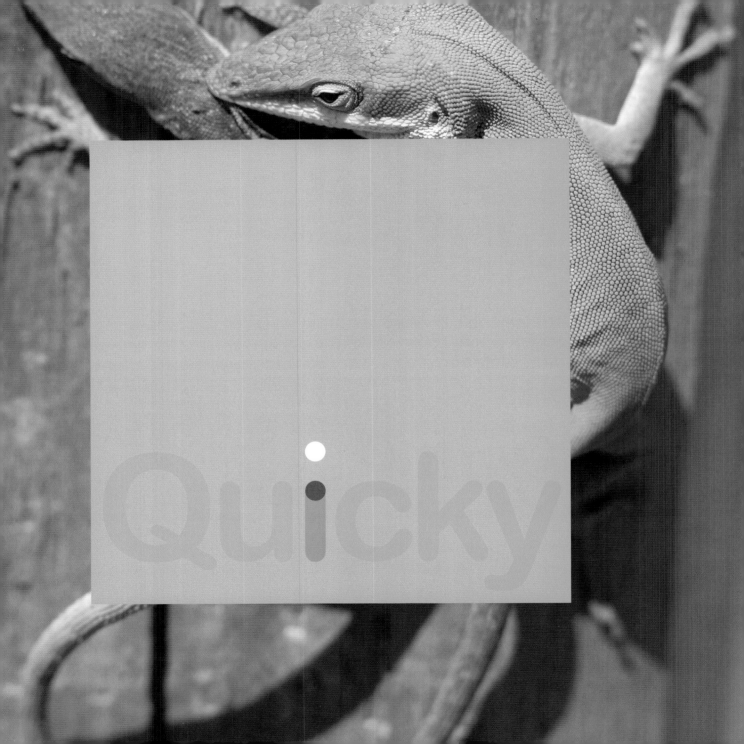

Mark Kingsley

A night owl, if we ever met one, Mark will always question, ponder, analyze, push, discuss, research, twist and observe subjects that are as mundane, incredible or as obscure as his wit.

SU: There is a wit and humor to your Word Its that is rare and very simple. What do you attribute it to? Where does it come from?
MK: Thank you, I work hard at it.

SU: To this date, your Word Its have been entirely typographical (except one). Why?
MK: It took a year or so for me to start submitting Word Its, and I only did so because I was so unhappy with the lack of rigor and thought of 95% of them. (Admittedly, when I get a copy of this book; I'll probably flip through it in disgust while stopping to admire my chosen submissions.)
In the spirit of being "the change you would like to see," I resolved to participate. And as a potential example to my fellow contributors, I also resolved to restrict the elements to just type and color.

To this day, there have been only a handful of imaged-based Word Its which intrigued me. Many of us are graphic designers; but few are truly art directors.

SU: You have adopted Gotham as your trademark typeface. Can you elaborate?
MK: Gotham is like tofu: it takes on the taste of whatever you mix it with. Additionally, how can one be a true New Yorker without loving a face called "Gotham"?

SU: What is your overall opinion of Word It?
MK: It could have been one of the greatest things about Speak Up—but instead, it's rife with doodles, dull whimsy and frequent lackluster political commentary.

I'm also saddened by the lack of participation by design-world "heavy hitters" who leave comments. They'll gladly spend time crafting a witty retort—with proper HTML links, mind you—but can't extend a few minutes for a Word It.

It's funny—and sad—how designers are quick to bemoan that they're not included in higher-level business discussions; but when given the opportunity for unrestricted graphic expression, they're either too shy or too important, uninterested or uninteresting.

On the other hand, lame Word Its offer insight into a person's written comments.

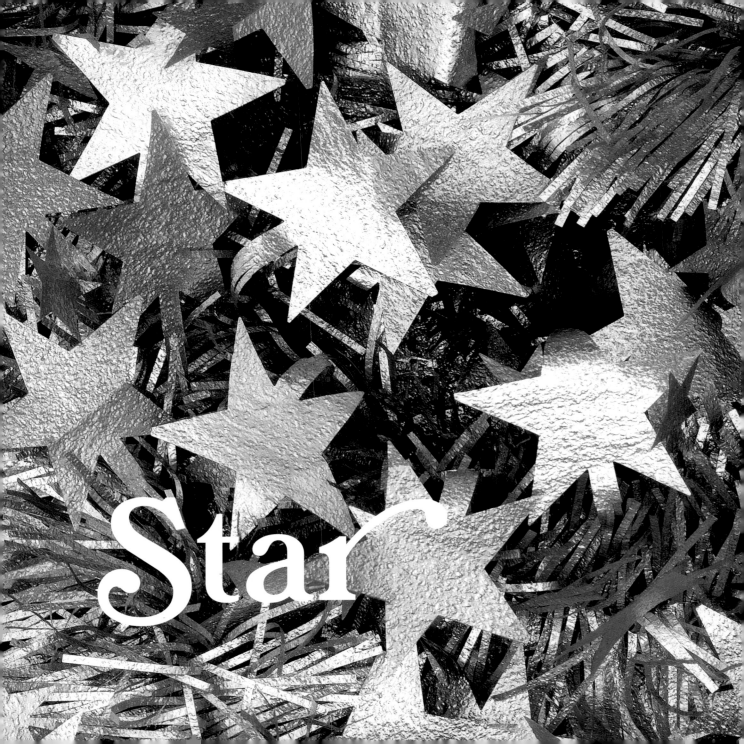

Date	December 2005
Total Word Its	59
Number of participants	50
Recurring themes	celebrity status possible stardom
Stars	93

If you are small as an ant, large as an elephant, rational as a human or as content as a golden retriever, you have in common this luminosity with your fellow cavemen and Tyrannosaurus Rex. Few things can be considered as universal and all encompassing as these tiny monstrous lights. A few things you, or others, might use them for:

· to mark the seasons
· a marriage proposal
· a cheesy logo
· glitter
· celebrity
· cutlery
· CD cover

· for location
· to discuss energy usage
· child's play
· wrapping paper
· priceless paintings
· to bundle up airlines
· to name a newspaper

Anyway, there are many current uses that were not previously explored, others that have been abandoned, and still some that shall forever be. One thing is for sure: we shall continue to wish upon a star by closing our eyes and hoping real hard.

Star is the Word It for December.

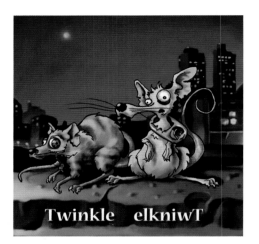

Twinkle elkniwT

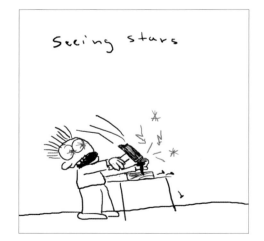

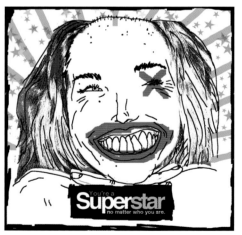

SU: You have developed a unique style in your work. Can you tell us how it came about?
JG: I didn't intentionally try to create a unique style. It's just the way my work naturally evolved to look. This illustration started out as traditional media and then went digital. I sketched and then inked the linework for the rats with a crow quill dip pen and Windsor & Newton ink. Then I scanned the linework and painted in the color in Corel Painter 8, with a Wacom Tablet. The first thing I do is loosely put down broad flat blocks of color with a large pastel, and then I go in and finish out the detail with various size acrylic brushes. Sometimes I get detailed enough where I remove the linework altogether. I left it in this case to keep the cartoony look.

Jeffrey Garczewski

Tonina

Mike Winkelmann

Harvey began to wonder if he'd misunderstood his friends' request for him to get a star to pop out of the cake.

David Werner

Nan Mellem

Divya Manian

SU: What do you admire from this lovely shining star?

DM: What I admire the most from Marylin Monroe is her pluck and courage.

She shines forever. Just like diamonds.

Jeff Barlow

Jeff is firmly set on branding, stating that "a brand is more than a set of colors, images, or fonts—it is a reflection of a company's business plan and operation standards. Brand creates an expectation in a customer's mind, and companies succeed when their products or services live up to these promises."

SU: In your original e-mail, you demonstrated your bafflement at everyone having forgotten The Star. Why do you think this happened?

JB: I think the double *R* threw people off.

SU: Why did you decide to detail the instruments, but not the faces?

JB: This was actually adapted from an experiment I did in two-frame animation a long time ago. My goal was to try and be completely iconic with the imagery. The list of essential elements included moptop hair, very distinct individual movement style, Paul's Hofner Bass and John's Rickenbacker. The faces didn't seem to be necessary. (Besides, I'm terrible at illustrating faces.)

SU: Each month, as you encounter the new word posting, what is your reaction like?

JB: I look for the new word with great excitement and anticipation. It's a reminder to me that when you throw a problem at a creative audience, there are limitless possibilities.

SU: What defines your participation in one word over another?

JB: It's simple gut instinct and inspiration. When I do a Word It, the idea usually hits me in the first two seconds, or it never does. Execution has taken me from minutes to hours, depending on the technique I decide to use; but the idea is always immediate. If I don't come up with an idea I love, I don't submit.

SU: What is your opinion, in a general sense, of the other submissions?

JB: I love looking at the collection every month. It's great to see what others are doing. Some hit me as immediately brilliant, while others leave me scratching my head, but there's not a single one I'd delete. Although I've always secretly wished that folks would try to tell their story without using the actual word itself in the artwork.

Date
January 2006

Total Word Its
97

Number of participants
76

Recurring themes
stand-out letters
punk
fashion

In the opposite direction
2

With or without a cause. It is up to us to take a stand and make a difference. In the petty, in life, in death, in the everyday, in the essential. For one or for many, it is our responsibility to rebel against that which we disagree with.

It does not matter if we are fifty years old or five; it does not matter if it is one or five hundred individuals. It does not matter if we are rebelling against institutions, organizations, governments, educational curriculums, parties, individuals, the system, the unions, our parents, our siblings, a stranger's words… as long as we stand for what we believe to be right.

Rebel is the Word It for January.

SU: Where do you draw the line between rebel and obnoxious?

JB: Some rebels do not know where to draw the line; they just don't care. For me, it depends on the situation.

Kelli Jensen

Gerardo Reyes

Joel Wheat

Christy Schreiber

Daniel Gavin

David Werner

SU: Please, tell us everything about this Word It.

DW: Rebellion confined to a 5x5 square isn't an easy task. Having briefly worked alongside Armin Vit and Michael Bierut during an internship at Pentagram, I felt like I could get away with saying something like this. Of course, I visit both communities often and have much love and respect for both. This rebellion really started at Pentagram; I used to prank call the other interns, pretending to be Mr. Bierut and making ridiculous demands like craving a peanut butter + jelly + spray mount sandwich.

re•bel v.; to bel again.

Definitions For the New World Order (c) 1984

SU: What was your inspiration? What led to this particular execution?

PP: Most of the entries that preceded mine were treating the word rebel as a noun, so I decided to look at it as a verb. Going for the unexpected ultimately led me to jump out of the normal semantic space for the word entirely—Orwell's book *1984* inspired a barely humorous idea into something worth considering. What happens to rebels in a global New World Order?

As convoluted as my thought process can get, when it comes to presentation, I always try a simple approach first. And dead center is about as un-rebellious as it gets.

Paul Pomeroy

Mark Andresen

Nina Kulhawy

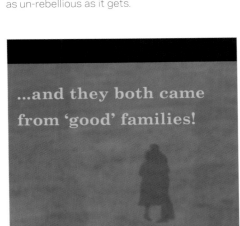

...and they both came from 'good' families!

Andrew Lehmann

Vladimir Vladimirov

Melanie M. Rodgers

SU: You have a unique style in your illustrations. Can you tell us how it came about?

MR: I was an undergrad during the heyday of illustrators like Glaser and Chwast, who continue their influence. Conceptually, I am drawn to this period's eccentric allusion to language, history and the vernacular; and formally, to its graphic flatness, decoration, color and typography.

I noticed their use of print production and tools as part of their *schtick*, and I adopted them too—rapidographs, ink, Cello-Tak, nonrepro pencil, photostats. Maybe working digitally is just as good, if not better, than the old school way—but when I need to be funny, or a smartass, I return to my production and illustration roots.

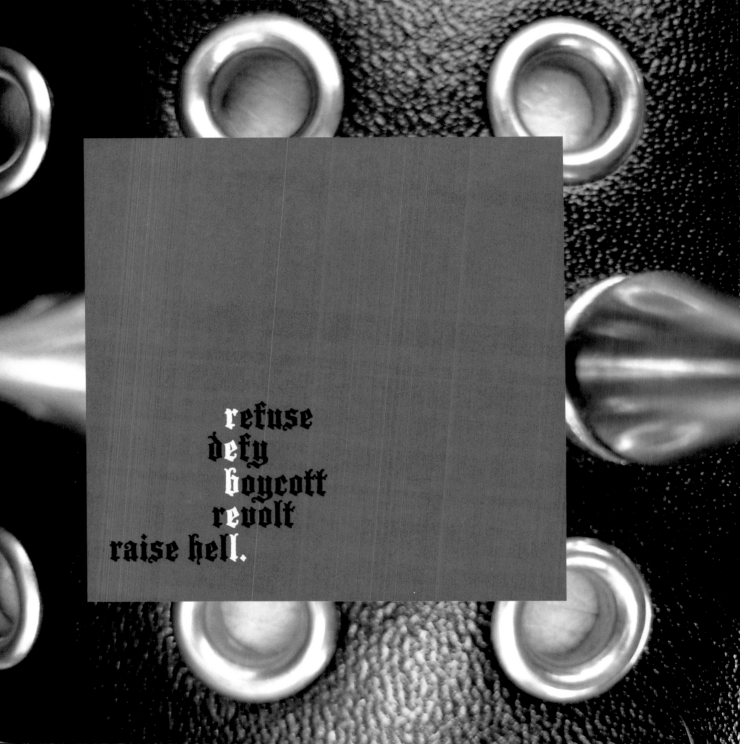

Rea Roberts

Born and raised in Trinidad and Tobago, Rea moved to the U.S. a decade ago where life placed her in the midst of design, a childhood passion. Today, her biggest challenge is self-imposed—to be the best designer that she can be.

SU: Were there any other words you wished to include?
RR: There were many other words. I actually brainstormed all the words I could think of that related to the word "rebel," then I got some help from the thesaurus. The final words were chosen because of their lengths and locations of letters necessary to form the word "rebel"—when arranged, I wanted the words to form an interesting negative space.

SU: Is the final piece close to your original idea, or did it evolve in the process?
RR: The concept is what I had planned initially. However, the color arrangement and font went through a few changes.

SU: Why did you go for blackletter?
RR: I chose the blackletter because it is edgy. When people want to be rebellious and get tattoos, they lean toward an edgy blackletter/gothic typeface.

SU: Would this have worked in pink and orange? What is it about the red/black/white combination?
RR: This piece could have been done in any color, but to me the most powerful combination of colors to design with is black and white. Because I needed three colors to make this design work, I added the ultimate power, red. I tried it several ways: black background, white words, red highlights and vice versa—but this is the final product.

SU: Do you play Scrabble?
RR: That's a funny question. I don't play Scrabble, but my idea was along the lines of a crossword puzzle.

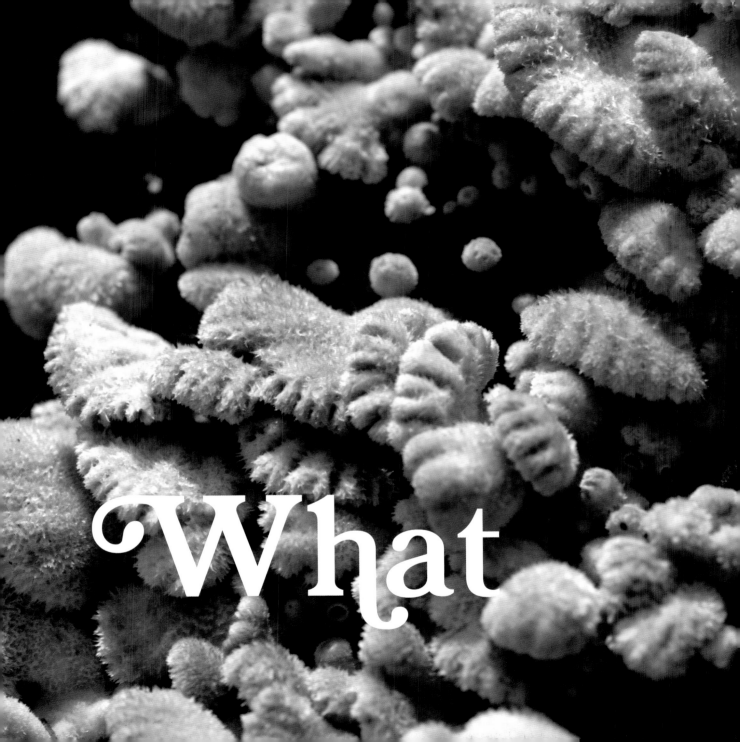

What

Date
February 2006

Total Word Its
67

Number of participants
9

Recurring themes
what the f?
hat
whatt

Number of ?s
56

What keeps you up at night?

What makes you smile?

What gives you shivers?

What elates you?

What causes storms in your head?

What makes you happy?

What makes you cringe?

What inspires your creative juices?

What gets you going?

What defines your choices?

What makes you hit the roof?

What makes you sing?

What scares you?

What makes you whisper?

What drives you?

What holds you back?

What is the Word It for February?

Katherine Earhart

Ramón Ferreira

Matthew Hunsberger

SU: What was your inspiration? And what led you to this execution?

KE: In the description of the Word It for that month, a question had been posed: "What keeps you up at night?"

Design is what keeps me up every night.

The cause: The most basic issues regarding design. The solution: Use of basic components of design (basic shapes, basic CMYK colors) to show my head literally spinning.

Zachary Letzring

Jeff Barlow

Monica McGregor

what pushes you?

SU: There is something very relatable to your Word It. Why do you think it is so?

MM: I think pretty much everyone wonders what's out there. There's the hope that the unknown is awesome and beautiful, but the fear that it's just miserable and hopeless, or nothing at all. We feel our smallness in the face of great power and mystery and try to understand it, even reach out to it, any way we can.

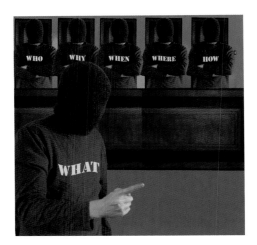

SU: This Word It seems to have gone through a complex process. Can you tell us about it?
JS: Thinking about "what" brought to mind Kipling's *Six Honest Serving Men*—from a poem I'd heard as a child. Though a light and humorous piece, I remember the image of six anonymous, relentlessly questioning men being a bit disturbing. The hat over my head probably came from Giorgio de Chirico's paintings (especially *The Disquieting Muses*), which were another childhood terror. But the shirts are definitely inspired by the henchmen in the 1966 film, *Batman*.

Thrown together in haste, I quite like the image of each of them bursting out of his own door ready to interrogate.

John Stephenson

Stephen Mockenstum

Howard Williams

SO
EVER
GUESS
THE HELL
IN THE WORLD
'S HAPPENING

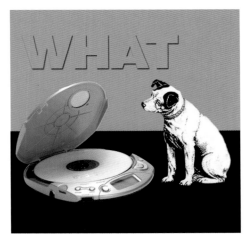

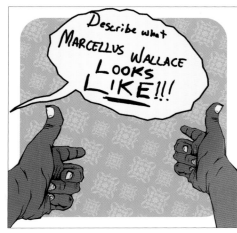

David Werner

Joel Wheat

Debbie Millman

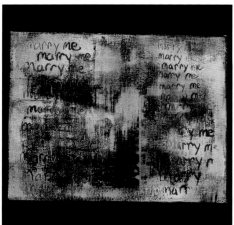

SU: What can you tell us about the time and situation in which this painting was created?
DM: This painting was created at the beginning of my first new relationship after going through a painful divorce. While I had recently fallen madly and passionately in love, I was still scared and fearful about having my heart broken and was unsure about where this new relationship would and could go. With this piece, I was trying to express the bold and the broken, as well as the hope and the fear that I was experiencing as I felt the excitement and the terror at once again opening my heart up to love.

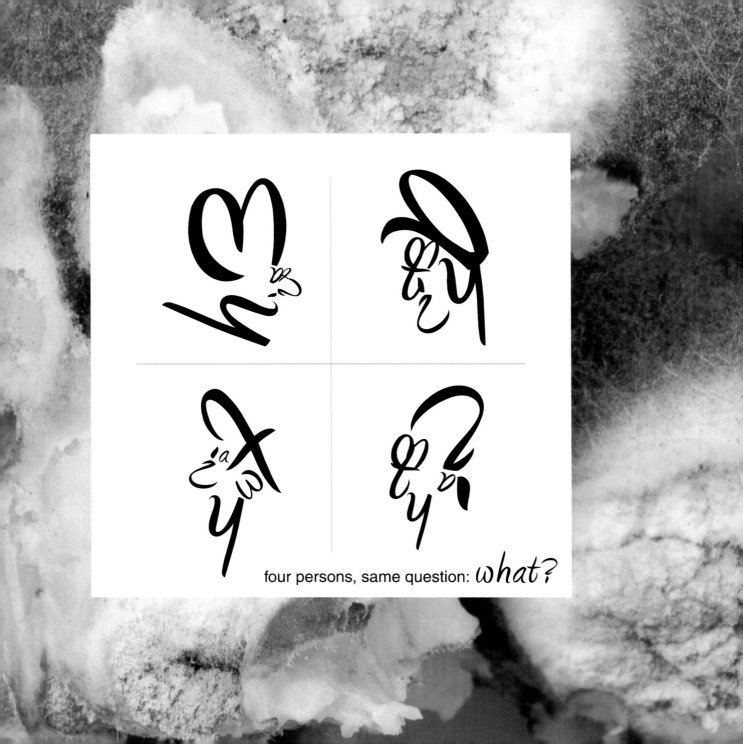

four persons, same question: *what?*

Vladimir Vladimirov

SU: Do you have a nickname for this kind of illustration?
VV: I've called it freestyle typo treatment.

SU: Can you tell us your typeface selection? And why that one in particular?
VV: The font is called Amienne. I chose it because of its good handwritten style, which looks like brush-painted hatches—the character's look becomes rather sketch-like.

SU: Is this a style you work with a lot?
VV: Yes. I love to typo-design, but it is far from my only passion in design.

SU: Do you give each one of these individuals personalities and stories?
VV: They are all one family—father, two sons and their grandfather. Starting from the top-left character and going clockwise:

1. Gonzo. The father, a chief cook. Strict and pedantic, with a terse and classic taste about life, food and everything family.

2. Peter. The oldest son, a student in Saint Petersburg. He is set in his antiglobalist philosophy, spending his days writing slogans against war—the new hippie.

3. Michel. Also a student—a new media artist. His main hobby consists of stealing street nameplates with unique or funny names.

4. Prodan. Their grandfather. Pirate and nobleman, evil and generous. Too many legends surround him. An idol to his grandchildren, not so for his son.

SU: Can you tell us about your process in creating these character-based characters?
VV: One little mastika with airan (buttermilk), and then—click, click, click with the little mouse.

Power

Date
March 2006
Total Word Its
95
Number of participants
64
Recurring themes
togetherness
energy
nature
Troubled or stern looks
9

P-O-W-E-R. With a period.
Power. With Initial Cap.
power. As a word.
w-o-r-e-p. As a group of letters.
Strokes on a surface.

Power can be abused and abusive. It can be challenging and challenged. Stable and unstable. Respected and disrespectful. Controlling or controlled. Right or wrong. Political, apolitical. Straight and crooked. Intentional, unintentional. Pre-planned, somewhat planned or spontaneous. Personal, public. Open, closed. High, low. Grounded, unfounded. Believed, mistrusted. Far, near, next door. Gargantuan or miniscule.

It all depends on where you stand in relation to it.

Power is the Word It for March.

Garen Litherland

Roberto Christen

Jean-Luc Diabolique

Ryan Hurry

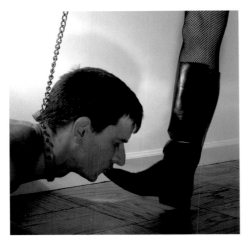

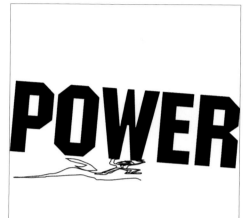

Jen Harders

Jason A. Tselentis

Frank McClung

of suggestion.

Bryony Gomez-Palacio

Lorenzo Morales

Patrick Mullen

Another *PowerPoint* Presentation!

- Kill me now
- I'm begging you
- **I mean it**
- Please strangle me
- Oh the humanity

SU: Your feelings regarding PowerPoint seem to be rather strong. Can you elaborate? **PM:** Ah, the scourge of PowerPoint. An overused crutch, it allows those with little to say to say it at great bulleted-point length, squeezing three minutes worth of information into a half hour of hell. Some speakers compound the pain by providing copies of their presentation, then reading the contents aloud for the illiterates in the audience. But at least most of the templates are ugly.

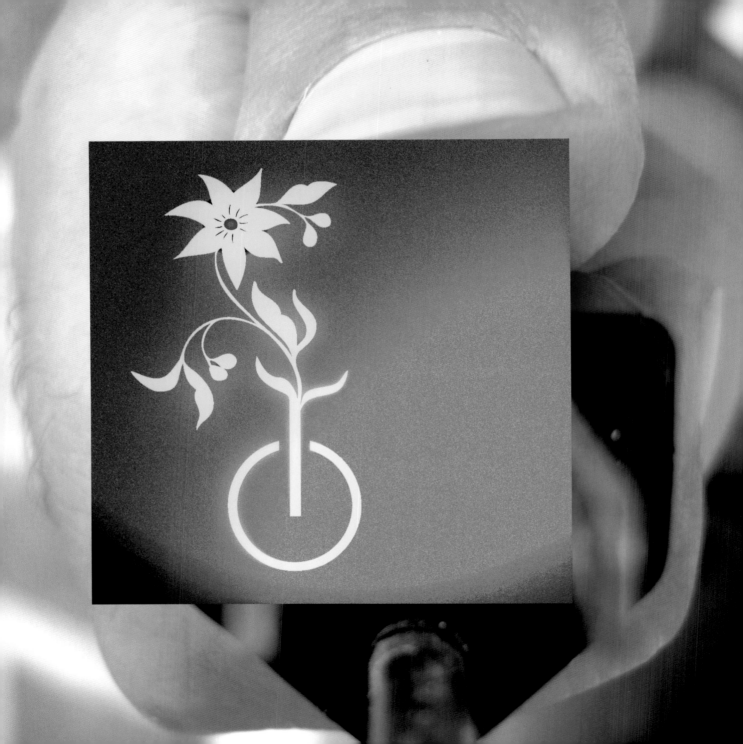

Joel Wheat

Having graduated from Portfolio Center in Atlanta, GA, Joel spends his free time trying to teach his dog, Chloe, to say, "I love you" and Googling pointless data to win arguments with friends.

As a toddler, he had a problem saying his "R"s.

SU: There are many meanings and interpretations in your Word It. Can you tell us about your inspiration?

JW: I wanted to represent the word "power" in a manner that would be subtler than what I assumed the other entries would be. I did not want to hit people over the head with POWER. I also wanted "power" to be a good thing, something positive.

SU: Is there a personal philosophy behind this execution?

JW: I enjoy trying to give something more than one meaning. Obviously, there is the instant reaction of "flower power," but there are many other ways to interpret it. Ambiguity is seldom a goal of a designer in the real world, but here, it is perfectly fine.

SU: How did you go about executing it?

JW: I spent more time on it than I should have. Let's just leave it at that.

SU: You are a constant participant of Word It. What keeps you coming back?

JW: It is like yoga for a designer. I constantly have to do work that other people have final approval of (I was a student when I started). It is nice to take a few minutes, relax and contribute something that is all me and does not take weeks to do from start to finish.

It is a quick design fix.

SU: What is your opinion, in a general sense, of the other submissions?

JW: I am just glad to see how many people have joined this fun little game. It is always nice when a bunch of individuals have such radically different interpretations—it says a lot about the individual and our community as a whole.

195
power

How

Date	This decade
Total Word Its	Hundreds?
Number of participants	Hundreds?
Recurring themes	TBD

The terrible twos are defined by Why.
The lifelong challenge is defined by How.

We might know Why, or we might ignore the reasons.
We can be aware of the When, or be oblivious to its time.
The What may be of consequence, or we could say that it matters not.
About the Where in this globalized sphere...

But the How.

The How can haunt our dreams or keep us awake. It can stop our hearts or keep us going. The How is as powerful as our drive, as important as our passion and as complex as our lives.

How is the Word It for this decade.

The next few pages are for you to create your own Word It for the word "how." Let your creative juices flow and your imagination run wild, for there is much to be done; but only you can create your unique interpretation of the word. When you are done, scan, photograph or recreate it in the computer and e-mail it to: howwordit@underconsideration.com

And go to www.underconsideration.com/speakup/how to see the submissions, as well as an exclusive behind-the-scenes account of the making of this book.

Sketch #1

Sketch #2

Sketch #3

Sketch #4

Sketch #5

Sketch #6

A few unknown facts

200 facts

HOT
in an interesting turn of events, Hot produced steamier solutions than Pleasure did, just four months earlier.

BOURGEOIS
the one time an anonymous entry was posted.

OOPS
nature and its wrath was a common thread.

TIME
the most submissions by one participant: 31.

SATURATED
with yellow and black being the predominant colors, a slight monochromatic word was achieved.

NIGHTMARE
with 32 entries, this word ranged from black to white and every tone of gray known to man.

GIANT
the word that ignited the largest amount of multiple submissions by a group of people (an average of four per person).

VIRTUE

the only time the number of entries matched the number of participants.

POWER

the last word to be included in this book, but not the last word.

facts

BRAND(ING)

a second turning point for Word It, as it received 62 entries.

REBEL

holds second place with 97 entries, losing only to Time with 107 contributions.

WHAT

we were in for a surprise at the amount of swearing, especially the "F-word."

BLAH

it would not be fair for us to keep quiet, as we should note that in a couple of instances, Speak Up and its commentary were—in one way or another—mentioned, represented or hinted at.

EXPECTATIONS

ranging from personal to world wide, from physical to philosophical, this everyone could relate to (no matter the age, sex, location or circumstance).

Index

Bold numbers represent interviews conducted with each individual.

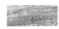

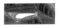

UNDERCONSIDERATION

210
Established in 2001, UnderConsideration is dedicated to the progress of the graphic design profession and its practitioners. At times intangible, its purpose is to question, push, analyze and agitate. At the moment, it is run by the editors of this book, Bryony Gomez-Palacio and Armin Vit, with the help of an army of young and vivacious—yet inanimate—chicks.

Through its cornerstone online initiatives like the (in)famous Speak Up and the up-and-coming Design Encyclopedia, along with sporadic publications, workshops and seminars, and the occasional discussions over coffee and biscotti or simple arguments while waiting for the bus, UnderConsideration will try to strengthen the notion of graphic design as a political, social, economical and culturally relevant profession among graphic designers.

Everything as we know it is up for discussion, reinterpretation and examination. Everything is under consideration.

Standing young, proud and curious, UnderConsideration's chicks represent our own stance on the profession.

Launched in September 2002, Speak Up ignited online design dialogue with furor and passion, capturing the attention of the design profession. In 2006, Speak Up was included in the third installment of the prestigious Cooper-Hewitt National Design Museum Design Triennial.

www.underconsideration.com/speakup

Every year, the most amusing, poignant and interesting commentary from Speak Up is printed in these adorable little booklets entitled *Stop Being Sheep*.

www.underconsideration.com/stopbeingsheep

Launched in September of 2005, The Design Encyclopedia is an ever-evolving, wiki-based collaborative resource that describes, tracks and explains culture, commerce, politics, media, sports, brands—everything possible, really—through design.

www.thedesignencyclopedia.org

More great titles...

Caffeine for the Creative Mind 250 Exercises to Wake Up Your Brain
By Stefan Mumaw & Wendy Lee Oldfield

Chock-full of useful 15-minute exercises designed to help creative types tap into their daily creative buzz, this book is perfect for limbering up your imagination on a daily basis. With simple and conceptual exercises, this guide will have you reaching for markers, pencils, digital cameras and more in order to develop a working and productive creative mindset.

ISBN-13: 978-1-58180-867-4, ISBN-10: 1-58180-867-4, paperback, 360 p, # Z0164

Ballsy 99 Ways to Grow a Bigger Pair and Score Extreme Business Success
By Karen Salmansohn

Full of dynamic advice, heavy on sass and sharply designed, Ballsy offers busy business people brash tips and tactics to immediately take control of their careers. The book's in-your-face attitude and humorous edge make it an inspiring guide for young professionals and a perfect gift for any career focused individual.

ISBN-13: 978-1-58180-816-2, ISBN-10: 1-58180-816-X, paperback, 208 p, #33496

Inspirability 40 Top Designers Speak Out About What Inspires
By Pash

Written and compiled by Pash, this book offers an original take on one of the most requested topics by graphic designers—how to stay inspired when working on a deadline. Interviews with 40 of today's top designers and insights into day-to-day inspiration make this a must-have tool for every graphic designer.

ISBN-13: 978-1-58180-555-0, ISBN-10: 1-58180-555-1, hardcover, 240 p, #33011

... from HOW Books

IdeaSpotting How to Find Your Next Great Idea
By Sam Harrison

Seasoned business pro Sam Harrison offers real and unique insight into the creative process, as well as exercises to help anyone generate viable business ideas. IdeaSpotting trains business people to step outside of their daily routing to find their next great idea by encouraging spontaneity and exploration.

ISBN-13: 978-1-58180-800-1 ISBN-10: 1-58180-800-3, paperback, 256 p, #33478

Creative Sparks An Index of 150+ Concepts, Images and Exercises to Ignite Your Design Ingenuity
By Jim Krause

This playful collection of rock-solid advice, thought-provoking concepts, suggestions and exercises is sure to stimulate the creative, innovative thinking that designers need to do their jobs well. Anyone working in marketing or design will find inspiration and new ideas with this creative guide.

ISBN-13: 978-1-58180-438-6, ISBN-10: 1-58180-438-5, hardcover, 312 p, #32635

Type Idea Index The Designer's Ultimate Tool for Choosing and Using Fonts Creatively
By Jim Krause

With conferences and blogs devoted to type, the subject continues to capture the attention of designers. Now there is a book that does the same. Type Index eschews the ponderous style found in other books in favor of a fresh, accessible approach. You'll find an in-depth examination of the creative and practical issues involved in all of the important areas, such as font anatomy, headlines and body texts. This is just the type of book you have been waiting for!

ISBN-13: 978-1-58180-806-3, ISBN-10: 1-58180-806-2, vinyl flexibind, 312 p, #33485

These and other great HOW Books titles are available at your local bookstore or from online suppliers. www.howdesign.com